THE
SISTINE
CHAPEL

On page 4: Michelangelo, *Ignudo*, Ceiling of the Sistine Chapel

In the same series:
Antonio Paolucci, *Raphael's Rooms*
Antonio Paolucci, *The Gallery of Maps*

ISBN 978-88-8271-038-5

© 2010 Edizioni Musei Vaticani
Città del Vaticano
www.museivaticani.va

Editorial direction: Direzione dei Musei

Copyediting: Ufficio Pubblicazioni Musei Vaticani

Photo credits: Servizio Fotografico Musei Vaticani

A publication by

s i l l a b e s.r.l.
scali d'Azeglio 22 - 57123 Livorno - Italia
www.sillabe.it - info@sillabe.it

Managing editor: Maddalena Paola Winspeare
Design: Susanna Coseschi
Copyediting: Giulia Bastianelli
Coordination: Barbara Galla

Translation: Catherine Burnett

Printed by Tipografia Vaticana

Reprint	Year
5 6 7 8 9 10 11 12 13	2015 2016 2017 2018 2019 2020 2021 2022 2023

Antonio Paolucci

THE SISTINE CHAPEL

EDIZIONI MUSEI VATICANI

sillabe

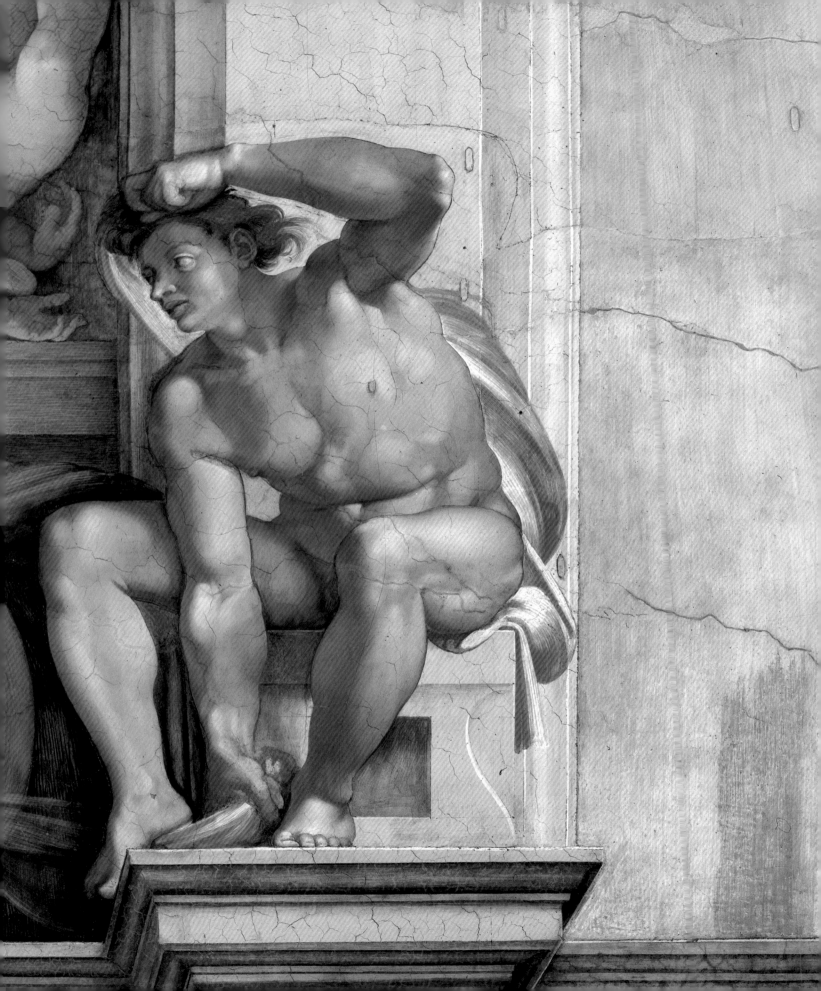

The Sistine Chapel 7

Illustrations 23

Appendix 123

The frescoes on the ceiling 124
The Last Judgement 125
Index of the illustrations 126

The Sistine Chapel

Every day at least twenty thousand people, or even twenty-five thousand in peak season, come into the Sistine Chapel – people of all origins, languages, cultures and religions or even people of no religion. The Sistine Chapel is the irresistible attraction, the object of desire for international museum-goers and migrants of so-called cultural tourism. The Sistine Chapel, however, though part of a museum visit, is not a museum itself. It is a religious place and a consecrated chapel; moreover it is a place which truly holds the identity of the Roman Catholic Church. The most important rites are celebrated here and this is the place where the Cardinals come together for the conclave to elect their pontiff. In addition to all this the Sistine Chapel holds a synthesis of Catholic theology. The history of the world (from *Creation* to the *Last Judgement*) is depicted here along with the destiny of Man redeemed by Christ. The Sistine Chapel is the story of Salvation for all men, and the affirmation of the supremacy of the Pope in Rome; it is the *sub Gratia* era of the Church which absorbs, transforms and creates the *sub Lege* era of the Old Testament; it is the Ark of the new and definitive Covenant which God established with the Christian people. It was not by chance that the architect Baccio Pontelli, who worked between 1477 and 1481 modifying and raising the previous structure, sought to give the Sistine Chapel the dimensions of the lost Temple of Jerusalem as written in the Bible.

Whoever enters the Sistine Chapel actually steps into an immense theological-cultural puzzle which is difficult to decipher at first glance. There are images (the *Creation of Adam*, *Original Sin*) which, in the mind of the viewer of Catholic origin, will evoke vague memories of childhood catechism. There are other images (the *Sibyls*, the *Prophets*, some episodes from the Old and New Testaments) which the average visitor will not recognise at all. Then there is Michelangelo who, like a bright, blinding light, commands everyone's attention with his all-encompassing notoriety making it difficult to understand the symbolic structure inside the Chapel (which the Tuscan artist also helped to create). Whoever enters the Sistine Chapel is immediately catapulted into the middle of a crowd and a bustling murmur of people, and can find themselves disconcerted, confused and awkward. My advice to first-time visitors with only an hour to spare is to take time to move away from the crowds and noise as much as possible and to look and look again carefully and then to come back and look once more at the frescoed scenes, and try to place them in time, in history and in the doctrine which gave rise to the images and their meaning.

These pages should be read before the visit and perhaps afterwards as well, when the visit is over, as they aim to help visitors understand the reasons behind the creation of

this supreme pinnacle of art and human spirituality between the fifteenth and sixteenth centuries. These words seek to convey the message the images hold and to give details about the artistic styles and the artists who brought them to life (not just Michelangelo but also Botticelli, Perugino, Ghirlandaio and Signorelli).

Pope Sixtus IV della Rovere was the great pontiff who brought the Renaissance to Rome and established a firm alliance destined to last through the centuries between the Church and the cultural world. In 1481 (the contract is dated the 27th October of that year) Pope Sixtus IV commissioned a group of prominent Umbrian and Florentine artists (Perugino, Ghirlandaio, Botticelli and Cosimo Rosselli, assisted by other collaborators such as Biagio d'Antonio, Bartolomeo della Gatta and Luca Signorelli) to decorate the Chapel with the Stories of Christ and the Stories of Moses on the right and left-hand walls respectively.

In the fifteenth century the mid-section of the Chapel was structured into twelve panels, six on each wall, whereas the higher tier carried false niches which held and framed full-length figures of the twenty-eight Popes after Peter. Originally, the sequence of Roman pontiffs began on the far wall, which Michelangelo would later cover with the *Judgement*. The figures depicted there included Christ with Peter, Linus and Cletus, the first Popes after the Vicar of Christ. In the centre, there was a masterpiece by Pietro Perugino of the *Assumption of the Virgin*, which was also pulled down to allow Buonarroti to create his vast fresco.

Hendrick van den Broeck, *Resurrection*

Matteo da Lecce, *Dispute over the Body of Moses*

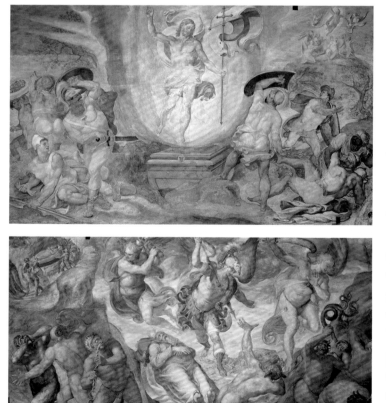

8

Even the larger scenes were originally more numerous, sixteen as opposed to the current twelve. Two of the absent scenes painted on the *Judgement* wall (*Finding of Moses*, *Birth of Jesus*) were destroyed to make way for Michelangelo, while the other two missing scenes on the entrance wall (*Resurrection of Christ*, *Disputation over the Body of Moses*) were lost when an architrave over the door collapsed in 1522. Only the *Resurrection of Christ* and the *Disputation over the Body of Moses* were recreated towards the end of the sixteenth century in a late Mannerist style by Hendrick van den Broeck and Matteo da Lecce.

The iconographic layout of the works completed in the fifteenth century in the Sistine Chapel is perfectly clear: Moses and Christ are the two lawmakers, Moses from the Old Testament and Jesus from the New Testament. The first Law is a prefiguration and a prophecy of the second, which is the

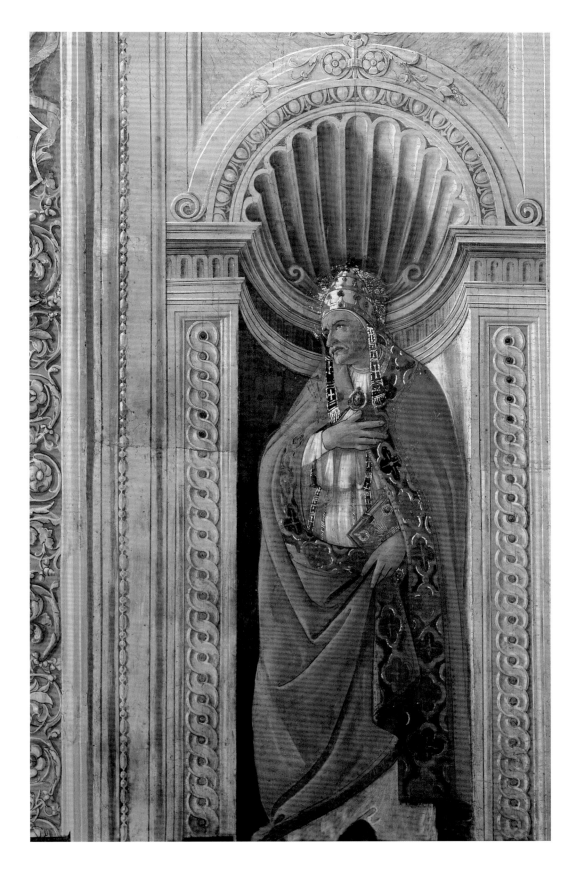

9

Sandro Botticelli,
St. Sixtus II

last and definitive Law instituted by Christ; this is the Law which the Church preserves and administers, sanctioned by the legitimacy of the apostolic succession (the series of Popes after Peter, the Vicar of Christ).

As visitors come into the Sistine Chapel their first glance falls onto the panel with the *Consignment of the Keys to St. Peter* by Pietro Perugino, a meaningful and strategic position selected to create an iconographical conclusion to the series of scenes on the right-hand wall. The vast and ancient square in the painting evokes the majesty of Rome and is broadened by the low perspective focussing on the central-plan building in the background while two monumental figures meet in the foreground. The first is

10

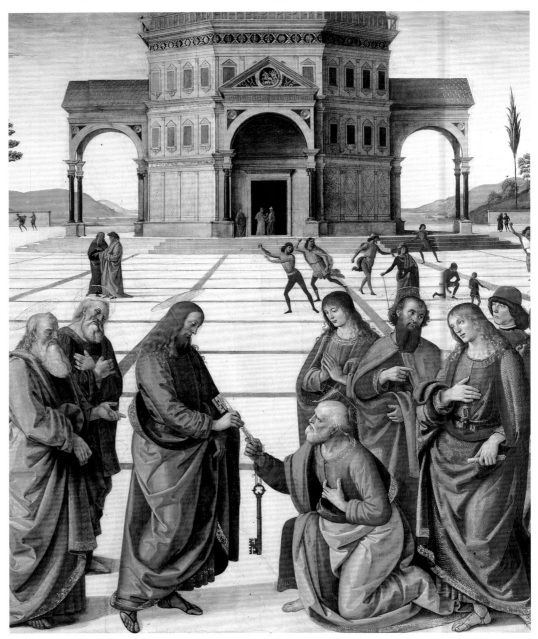

Pietro Perugino,
*Consignment of the
Keys to St. Peter*

Christ, who entrusts the keys of the Kingdom to the Vicar as he kneels in front of him to receive them. The whole scene from the evangelical episode of 'Tibi dabo claves' is infused with harmony, solemnity and captivating silence. Peter's leadership and thus of the Roman pontiffs – the rock on which the Universal Church is built – is represented with magnificent simplicity and evocative naturalness.

There is one thing which visitors must keep in mind when they find themselves in front of the frescoes commissioned by Sixtus IV della Rovere. They must remember that the Mosaic series and the Christological series are interlinked, each one mirroring the other. On the right Pietro Perugino painted the *Baptism of Christ* and on the opposite wall we can see its counterpart, *Moses' Journey into Egypt*, also by Perugino. These two scenes mark the beginning of the two stories and in a continuation of the same pattern, the panel with the *Temptations of Christ* by Botticelli is situated in front of another scene by the same artist, the *Temptations of Moses*, which shows the prophet blinded by rage and committing murder. The *Crossing of the Red Sea* by Biagio d'Antonio is a prefiguration of the *Vocation of the Apostles* by Ghirlandaio, while the fresco with *Moses receiving the Tablets of the Law* and the *Adoration of the Golden Calf* reflects the *Sermon on the Mount*, both by Cosimo Rosselli. The *Consignment of the Keys to St. Peter* by Perugino is situated opposite Sandro Botticelli's *Punishment of Korah, Dathan and Abiram*, while the *Last Supper* by Cosimo Rosselli faces the *Testament of Moses* by Luca Signorelli.

In terms of doctrine and Catholic theology, the Old Testament is a prophecy of Christ's coming as it anticipates and prefigures the Gospel. No other place expresses this concept with such persuasive effectiveness; it spans and supports the whole history of Christian thinking like a great architrave.

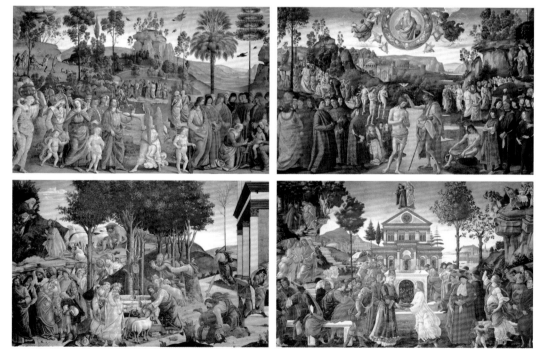

Fietro Perugino, *Moses' Journey into Egypt*

Pietro Perugino, *Baptism of Christ*

Sandro Botticelli, *Stories from the Life of Moses*

Sandro Botticelli, *Temptations of Christ*

In order to grasp the meanings portrayed in the fifteenth-century section of the Sistine Chapel, two distinct, fundamental and accessible planes of understanding must be taken into account – a theological scriptural plane and art historical plane. The first can be summarised in the following manner – the great chapel of the Popes of Rome, as large as the Temple of Jerusalem, is the Ark of the new Covenant, a synthesis and illustration of the mission and destiny of the Church, and a portrayal of the history of salvation. The counter-positioned cycles of the life of Moses and Jesus tell us about how the new Law incorporated and definitively moved beyond the Old Testament. The uninterrupted series of pontiffs (Peter's successors) shows and assures us that the new Law is kept and administered by the Church which Christ himself created (the *Consignment of the Keys to St. Peter*).

Before the course of history, however, there came the *Creation of the World* and then, after the course of history, the *Last Judgement* would come upon each and every human being. This is the second part of the Sistine Chapel, the part which concerns only Michelangelo and which took shape in two separate stages: between 1608 and 1512 (the ceiling) and between 1536 and 1541 (the *Judgement*). Before we come to that, however, first visitors must notice, or at least prepare themselves to notice the second plane, the more literally art historical one, which Sixtus IV's Chapel contains.

When the Pope inaugurated the pictorial cycle before the plaster had even dried on the 15th August 1483, the festival of the Assumption, we can affirm that the Renaissance had arrived in Rome. The cycle's twelve scenes are the result of a form of teamwork which had never before been seen in large-format painting in Rome; the works were brought together by adept artists, who were able to homogenise and balance the works without taking away from their individual variations and stylistic traits. The Sistine artists brought many

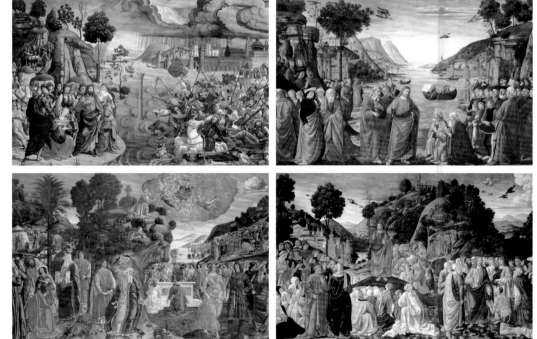

Biagio d'Antonio, *Crossing of the Red Sea*

Domenico Ghirlandaio, *Vocation of the First Apostles*

Cosimo Rosselli, *Moses receiving the Tablets of the Law*

Cosimo Rosselli, *Sermon on the Mount*

things to the Vatican including perspective, naturalism, illusionism, compositional and scenographic knowledge, and understanding of colours; the infinite world rendered infinitely seductive by the clear beauty and the human expression of feelings, emotions and affections. It is easy to imagine the admiration and amazement the frescoes in the Chapel must have excited amongst the Papal Court and in the Roman and Italian artistic world.

The frescoes in the Sistine Chapel were completed in an incredibly short amount of time, between the autumn of 1481 and the summer of 1483, and they form the most extraordinary pictorial anthology of the Italian Renaissance at its highest point.

Pietro Perugino completed three scenes (the *Baptism of Christ*, *Moses' Journey into Egypt*, and the *Consignment of the Keys*), while another great fresco painter of the time, Domenico Ghirlandaio, completed one scene (the *Vocation of the Apostles*). The noteworthy Florentine and Tuscan artists the Pope called upon included Cosimo Rosselli with *Moses receiving the Tablets of the Law* and the *Adoration of the Golden Calf*, the *Sermon on the Mount* and the *Last Supper*; Biagio d'Antonio with the expressively dramatic *Crossing of the Red Sea*; and Luca Signorelli assisted by Bartolomeo della Gatta and Botticelli with the *Testament of Moses*. A special mention must be reserved for Botticelli and his swift drawing style with sinuous and harmonious lines forming wonderfully vibrant scenes full of feeling, grace, restlessness and passion. Three of the scenes are by Botticelli: the *Temptations of Moses* opposite the *Temptations of Christ* and the *Punishment of Korah, Dathan and Abiram*. These three large frescoes by Botticelli constitute the most important set of works in his oeuvre, comparable only to his famous masterpieces at the Uffizi Gallery. They are examples of the artist's work at his highest stylistic level and they are conserved in almost perfect condition.

Sandro Botticelli, *Punishment of Korah, Dathan and Abiram*

Pietro Perugino, *Consignment of the Keys to St. Peter*

Luca Signorelli and Bartolomeo della Gatta, *Testament of Moses*

Cosimo Rosselli and Biagio d'Antonio, *Last Supper*

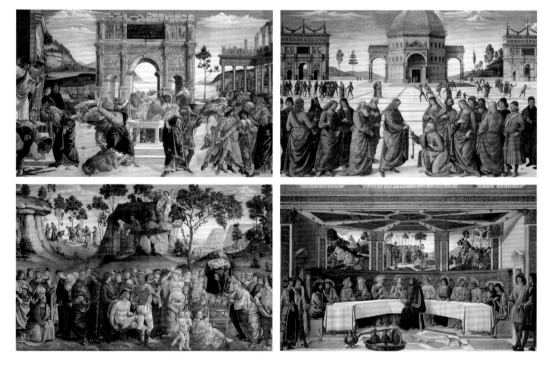

My advice to visitors would be to dedicate sufficient time to Botticelli and Perugino, as well as Ghirlandaio and the other Tuscan and Umbrian masters in the Sistine Chapel before being seized immediately by Michelangelo, partly because the best way to grasp Buonarroti's style is first to understand the cultural context in which he began to work. It was, in actual fact, this ensemble of excellence from Ghirlandaio (Michelangelo was a pupil in his *atelier* as a teenager), to Botticelli and Perugino (Michelangelo had the chance to meet him before he died), which gave rise to the vertiginous growth which, just over twenty years later, would lead to the frescoes on the ceiling.

This brings us to the fatal year of 1508, an extraordinarily important date in the history of art. In that year Julius II, a Pope who seemed to love politics and war more than he loved painting, entrusted the decoration of his private rooms (the Rooms of the *Signature*, *Heliodorus* and the *Borgo Fire*) to a boy of twenty-five years old, Raffaello Sanzio of Urbino (Raphael), and the decoration of the Sistine Chapel ceiling to Michelangelo Buonarroti, a young man of thirty-three years old. The contract is dated the 8th May 1508 while the inauguration of the first part from the entrance to the centre took place on the 15th August 1511. The whole project was completed on the 30th October 1512. The artist was still in his prime when he worked uninterruptedly for four years frescoing the ceiling of the Sistine Chapel. He tackled the task with intent energy and hard determination and he was intolerant of helpers and assistants; he worked alone as if engaged in a duel, hand to hand combat with the plaster destined to be covered in images.

It is no secret that Michelangelo was an extremely efficient engineer of his own image. His exceptional, exacting, solitary and irascible nature and his misanthropic, surly temper were undoubtedly distinctive character traits. Buonarroti not only did nothing to conceal these traits or change his behaviour, he fuelled his image to create an existental heroic profile which was then enhanced in contemporary literature. Through his biographer, Condivi, and Giorgio Vasari in the *Lives of the Artists* (1550, 1568) he constructed a historiographic myth of the *divine* Michelangelo, a supreme vertex in the centuries-old succession of the arts.

Exactly how the Sistine ceiling project progressed and how the artist wanted to present himself can be gleaned from a document kept in the archives of the Buonarroti House in Florence. It is a small sheet of paper written in the artist's hand with a caricature of himself painting in an uncomfortable position along side the following verses:

I've grown a goitre by dwelling in this den-
as cats from stagnant streams in Lombardy,
or in what other land they hap to be-
which drives the belly close beneath the chin:
my beard turns up to heaven; my nape falls in,
fixed on my spine: my breastbone visibly
grows like a harp: a rich embroidery
bedews my face from brush-drops thick and thin.
My loins into my paunch like levers grind:

my buttock like a crupper bears my weight;
my feet unguided wander to and fro;
…

This sonnet, addressed to the artist's friend Giovanni da Pistoia, is grotesque, surreal and sulphurous. It tells of a man disconcerted and troubled by his work, a man who doesn't feel right for the job, a sculptor working on fresco painting, a man who feels angry, disappointed and despondent, though he can still exalt the arduous glory of art with the two beautiful lines: '*a rich embroidery bedews my face from brush-drops thick and thin*'.

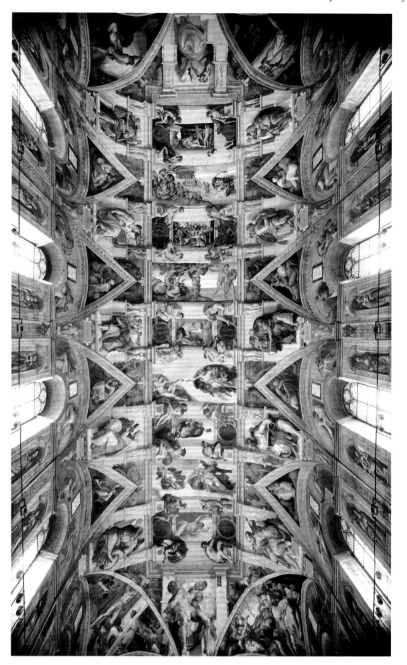

Ceiling of the Sistine Chapel

To all intents and purposes Michelangelo worked alone on the scaffolding in the Sistine Chapel. He barely made use of the assistants his Florentine friends Francesco Granacci and Giuliano Bugiardini procured for him. He encountered some problems at the beginning because he did not completely master the fresco technique, although he soon found the best scale and rhythm to work to.

In actual fact Michelangelo was left to organise the work and design the scenes on the ceiling as he wished, making use of the expertise of whomever he liked. The contract drawn up in 1508 laid out an iconography which the artist completely reinvented. A staggering universe of facts and figures unfolds in a trompe l'oeil architectural framework, a masterpiece of perspectival illusion.

In the centre, in nine rectangular frames (four main areas and five smaller sections), nine episodes from the book of Genesis are portrayed: the *Separation of Light and Darkness*, the *Creation of the Sun, the Moon and the Plants*, the *Separation of Land from Water*, the *Creation of Adam*, the *Creation of Eve*, *Original Sin*, *Noah's Sacrifice*, the *Flood*, and the *Drunkenness of Noah*. This is the iconographic order of the episodes but Michelangelo worked on them in reverse as he began to paint the ceiling from the entrance wall inwards.

15

Whoever looks at the ceiling of the Sistine Chapel in its iconographical order, following the episodes of Genesis one by one, will realise that as the scenes progress from the far wall with the *Drunkenness of Noah* and the *Flood* (the first to be painted) towards the beginning of the biblical story, they become simpler and acquire more grandeur of form and more confident foreshortening. It becomes evident that Michelangelo gradually realised the expressive potential of fresco painting and discovered how to use the technique to the greatest effect in his creations.

The surprising thing about the ceiling frescoes with the scenes from Genesis is Michelangelo's formidable capacity to radically and ingeniously reinvent long-standing, firmly established iconographies. The Eternal Father separating light from darkness is an almost acrobatic figure which engulfs the primordial nothingness below. There is a whirlwind of creation with the light of day on one side and the darkness of night on the other – a sudden flash of lightening from which everything began. Michelangelo thus gave form to his concept of the *big-bang*. Even the greatest artists have always represented the creation of Man as a more or less literal translation of the bible. God formed man of dust from the ground, and breathed into his nostrils the breath of life; and man became a living being. Michelangelo reset the traditional iconography and invented such a new and evocative form of imagery that five centuries later it is still capable of exciting emotion and amazement. There is absolutely no sign of ingenuous materiality in Michelangelo's *Creation of Adam*. The first man is set down on earth, and comes from the earth, but it is the spark which bursts out from God's index finger to touch his which transforms him into a living being, seemingly by the passing of an electric current. God arrives in a glorious swirl magnified by his red cloak, engulfing the angels of his retinue as if they were protected by a wind-swollen sail, a personification of the Almighty's power. Some people, drawing on an evocative, albeit fanciful and improbable hypothesis, have identified a human brain in the group of God the Father surrounded by angels, almost as if the scene were a manifestation of a creationist Michelangelo as a precursor of "intelligent design".

The Book of Genesis recounts the beginning of time but time is moving towards the redemption of the human race represented by the coming of Christ. The Prophets and Sibyls herald it from depths of the centuries and the Lord's ancestors prepare for it over the generations. We realise immediately that a formidable and faultless theological structure governs the design of the vault. The magnificent male figures or "ignudi" – in the corners and seated on plinths – frame the scenes of Genesis holding up oak-leaf festoons alluding to the name and glory of Pope Julius della Rovere. Although the symbolic role of the twenty "ignudi" is not altogether understandable, the significance of the twelve enormous figures of the Seers is completely clear. The images include seven prophets from the Old Testament and five prophetesses from the classical tradition. They all originate from the depths of history, from the *sub Lege* and *ante* or *extra Legem* periods. They represent hope and expectation, and they prophesise the coming of the Saviour and His incarnation which is mysteriously awaited by the generations of ancestors set in the underlying parallel series of the webs of the lunettes.

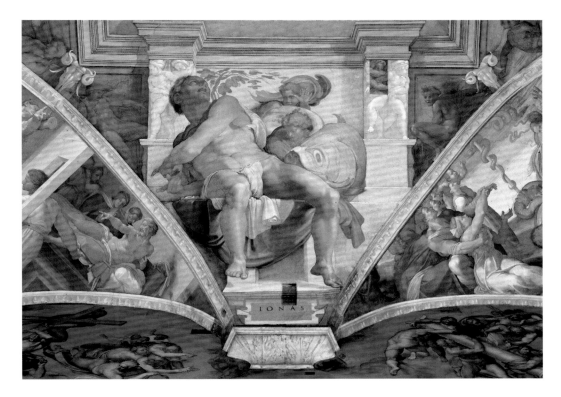

The prophet Jonah sits in a particularly privileged position and carries a special meaning. The Bible says that Jonah refused to do the Lord's bidding when he instructed him to preach to the sinners of Nineveh. Subsequently the prophet was thrown into the sea by the crew of the ship which had given him passage and was swallowed by an enormous fish before being vomited up alive on the beach three days later.

The prophet is therefore a symbol of forgiveness and repentance, two of the supreme sacramental powers of the Church, but he is also a symbol of Christ who rose from the dead after three days. Many years later when Michelangelo painted the *Judgement*, he placed Jonah immediately above the resurrected Christ, who comes to judge the living and the dead. The scriptural connection thus appears to be perfect.

We can try, at this point, to reflect once again upon the whole of the Sistine Chapel ceiling swarming with hundreds of figures, an immense undertaking which Michelangelo consigned on the 30th October 1512 after four years of constant work.

In the centre of the Genesis scenes Michelangelo recounts the cosmogony, the origins of Man, Original Sin, and the fatal burst of Evil in the story (the *Flood*, the *Drunkenness of Noah*...). The human race is forever consigned to wickedness, violence and death. God, however, does not abandon Man. He intercedes to protect the chosen people in the episodes of the Bible portrayed in the pendentives in the corners of the ceiling: the *Punishment of Haman* who, as a minister of Ahasuerus, wanted to wipe out the Jews; the *Bronze Serpent* raised above the tribes of the exodus to cure them from the fiery serpents' bite; the *David and Goliath*, where the young boy slays the giant; the *Judith and Holofernes*, where the widow Judith saves her people by decapitating the wicked Holofernes.

Michelangelo,
Prophet Jonah

God does not withdraw from the course of history, but allows men to cultivate expectation and hope. The Prophets and Sibyls pronounce, in the fullness of time, the coming of Christ, while his arrival on earth is slowly and painstakingly prepared for by the generations of ancestors.

The story of the Sistine Chapel could have come to an end on the 30th October 1512 but instead, it drew to a close more than a quarter of a century later with the *Judgement*, the supreme work of art of Michelangelo's maturity frescoed between 1536 and 1534 under Pope Paul III Farnese.

At that point in time Italy and Europe had changed considerably compared to the "golden age" of Julius II. The Sack of Rome occurred in 1527, the spiritual unity of the West was split by evangelical reform, and the Catholic Church had retreated in defence to organise the Council of Trent and to make plans for the difficult and astute reconquest the history books call the Counter-Reformation. Italy, impoverished and subjected to the political control of the great powers was then, with the exception of Venice, a country with limited sovereignty.

In these dramatic and calamitous times, which saw the loss of Florentine liberty after the Medici family's return to power supported by the Spanish, Michelangelo, then in his sixties, the indomitable republican and democratic who had defended Florence as a military engineer when Florence was under siege (1530), was about to take on the ultimate pictorial feat. The *Judgment* took five years to complete between 1536 and 1541. The iconographic concept was in a sense obligatory. Given that the Sistine Chapel as a whole recounts the history and destiny of Man created by God and entrusted to the salvific guidance of the Church, the presence of the *Judgement* is essential. After the Genesis, after the affirmation of the Laws of Christ which incorporate and continue on from the Laws of Moses, and after the series of Popes with a divine mandate to keep the keys and thus the power to dissolve and bind, every single person will come to the end of the course of history.

The *Judgement* is a universally recognised term used to describe this great fresco. The word is correct but it would be more fitting to describe it as a parousia; the last coming of Christ on earth to judge the living and the dead, to cancel out everything, time and history, forever. Whoever looks at the *Judgement* can be mislead into thinking that there is no wall, and that their gaze opens out into indefinite space made up of ice-cold, blue sky. In this unrealistic, metaphysic dimension where time no longer exists because the history of Man has ended, everything comes to pass simultaneously: the Resurrection of the Bodies and the Judgement, Hell and Paradise.

'And he that sat upon the throne said, "Behold, I am making all things new". And he said unto me, "Write: for these words are true and faithful". And then he said unto me, "It is done. I am Alpha and Omega, the beginning and the end".' (Revelations, 21)

Michelangelo's Judge does not sit on a throne, he is beardless and looks like a young glorious and victorious athlete, but the artist was able to represent the theological anguish of the parousia with extraordinary effectiveness. Time is finished, history is no more, and there is no room for mercy or forgiveness. Even the Church has completed its task. Peter

returns the keys to Christ which Jesus consigned to him, just as Perugino depicted many years previously. Even the Virgin Mary no longer has a role to play. She clings, resigned, to her Son as her duty as Mother of Mercy, Gate of the Heavens and Queen of the Sinners and the Afflicted has now been definitively fulfilled; everything has been decided.

People experience a terrifying feeling when they stand in front of Michelangelo's great mural. It is a sensation Pope Paul III Farnese must have felt when – according to reports – he fell to his knees in shock with tears in his eyes on that October day, the eve of All Saints in 1541 when the *Judgement* was uncovered.

Some fundamental iconographical indicators are needed in order to understand the *Judgement*. The elements which set the composition alight, almost like sparks setting off a terrifying mechanism, are the trumpet-playing angels who call the dead to be resurrected. They form a group of young naked figures, spreading open two books: the small one calls the just to Paradise while the large one condemns the damned to Hell, for many may be called but few are chosen. The evidence presented at the Tribunal of Judgement is formed by the instruments of the Passion of Christ, held by a swirling group of angels in the higher part of the fresco: the cross, the column of flagellation, the crown of thorns and the sponge.

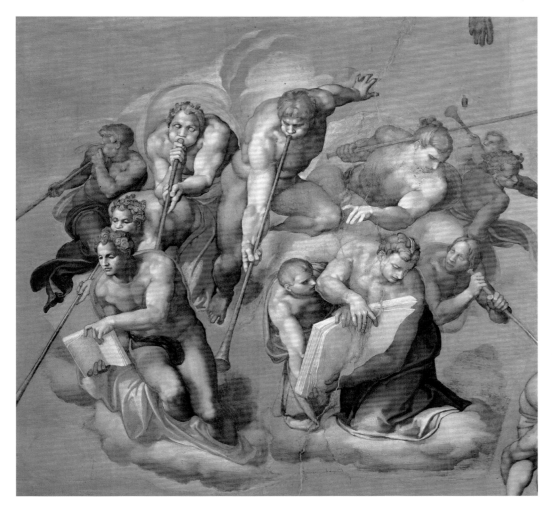

Michelangelo, *Last Judgement*, *Trumpet-Playing Angels*

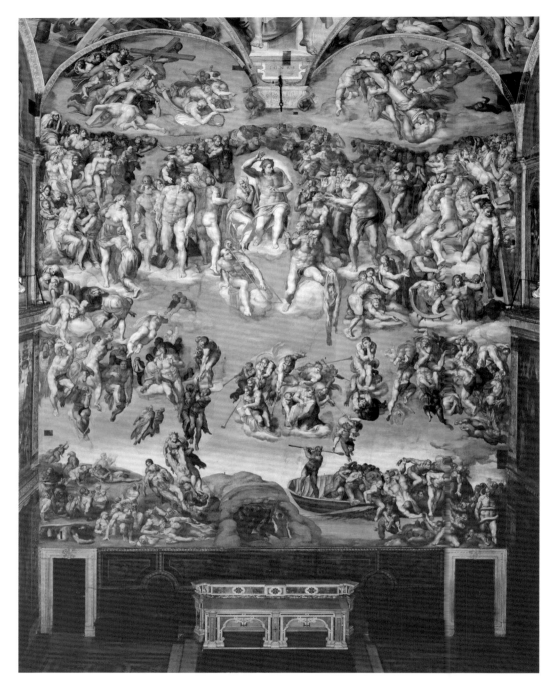

Michelangelo,
Last Judgement

Christ died on the cross to help us and so we shall be judged; the strength of our faith to the cross will allow us be saved or cause our damnation – these are the meanings behind the symbols of the Passion. The Church triumphant is set around the Celestial Judge in a hemicircle in Michelangelo's fresco. There is a caricature-like, anamorphic self portrait of the artist himself in the flayed skin which, as a symbol of his martyrdom, St. Bartholomew is holding. There are angels and demons contending for the resurrected while the oven of Hell seethes and blazes from the cracks in the earth.

Now we come to the naked figures, a boundless representation of beauty and the glory of

the human body intended to disconcert and trouble the most God-fearing souls. According to documents from the time, this feeling of discomfort was roused when the *Judgement* was unveiled to the public. Man comes to be judged naked, in the prime of his youth and physical fitness to return to the Almighty in the splendour of form He himself gave us when He made us in His image. This is unexceptional from a theological point of view, although it does not lessen the effect of the bare breasts, buttocks and genitals, which many people considered perturbing and unacceptable. After Paul III died in 1549, his successor tried quietly to advise Michelangelo to conceal all the nudity in some way. His ironic and scornful reply, as written by Giorgio Vasari, is now infamous: 'Tell the Pope that this is trivial thing which can be easily dealt with, he would do better to turn his attention to dealing with the problems of the world, because paintings can be quickly dealt with'. As it happened, while Michelangelo was alive nobody dared touch his masterpiece. It was only after his death in 1564 that the parts which were, or could be interpreted as "scandalous", were painted over with drapes and retouched. The unpleasant task was carried out by the painter Daniele da Volterra, an excellent artist who thereafter suffered permanent damage to his reputation and became known by the nickname "braghettone" ("breeches-painter").

Michelangelo's *Judgement* has been studied, commentated on and celebrated in all the languages of the world. There have been so many works written about it that they would fill a library. One particular opinion which strikes me as being acutely penetrating and decisive was written by a genial Florentine character and a friend of Michelangelo, Anton Francesco Doni. In a letter dated 1543, two years after the fresco's inauguration, Doni wrote to Buonarroti: 'the day Christ comes, he must make it so that everybody behaves, so that everybody looks as beautiful, and so that hell has the same shadows as you have painted, because it could not be any better.' This is essentially saying: when the actual Day of Judgement comes, our Lord should abide by the scenes Michelangelo has already painted because not even He would be capable of imagining a better one. Doni's hyperbolic paradox, on the cusp of irreverence, is the most inspired assessment ever expressed about the *Judgement*.

From 1979 to 1999 the Sistine Chapel underwent an extensive restoration, which excited and divided scholars and public opinion all over the world. Under the direction of Fabrizio Mancinelli and management of Gianluigi Colalucci, restorers started work on the two scenes on the entrance wall then moved onto the whole cycle of portraits of the Popes, Prophets and Sibyls (1980–1984) before coming to the ceiling with the stories from Genesis (1985–1989) and finally the *Judgement* (1990–1994). The High Mass celebrated by John Paul II on the 8th April 1994 marked the end of the most spectacular as well as the most disputed and admired restoration of the century. Immediately afterwards, for understandable reasons of uniformity, restorers returned to work on the parts of the Sistine Chapel completed in the fifteenth century, that is to say the areas frescoed by Perugino, Ghirlandaio, Botticelli and various other artists. The final result can now be described as one of the greatest and most successful feats of the twentieth century.

Bibliographical Note: C. Acidini Luchinat, *Michelangelo pittore*, 24 Ore Cultura, 2007; H. W. Pfeiffer, S. J., *The Unveiled Sistine. Iconography of a Masterpiece*, Jaca Book, Libreria Editrice Vaticana, Musei Vaticani, 2007

Illustrations

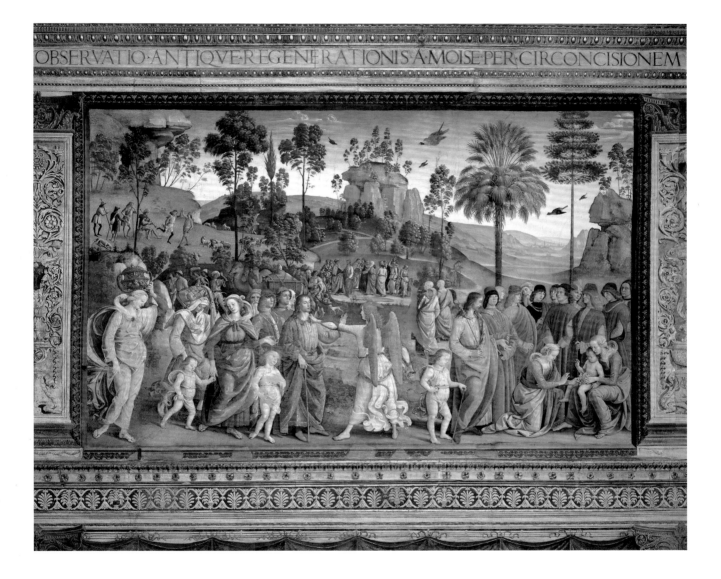

Pietro Perugino, *Moses' Journey into Egypt*

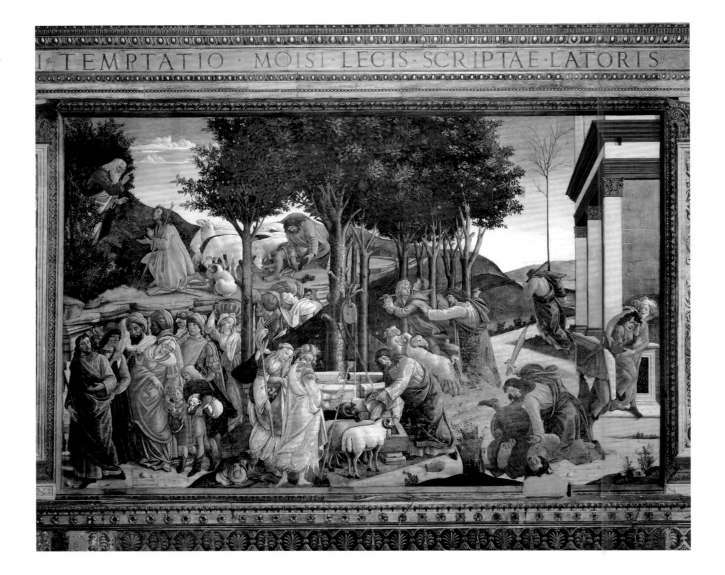

Sandro Botticelli, *Stories from the Life of Moses*

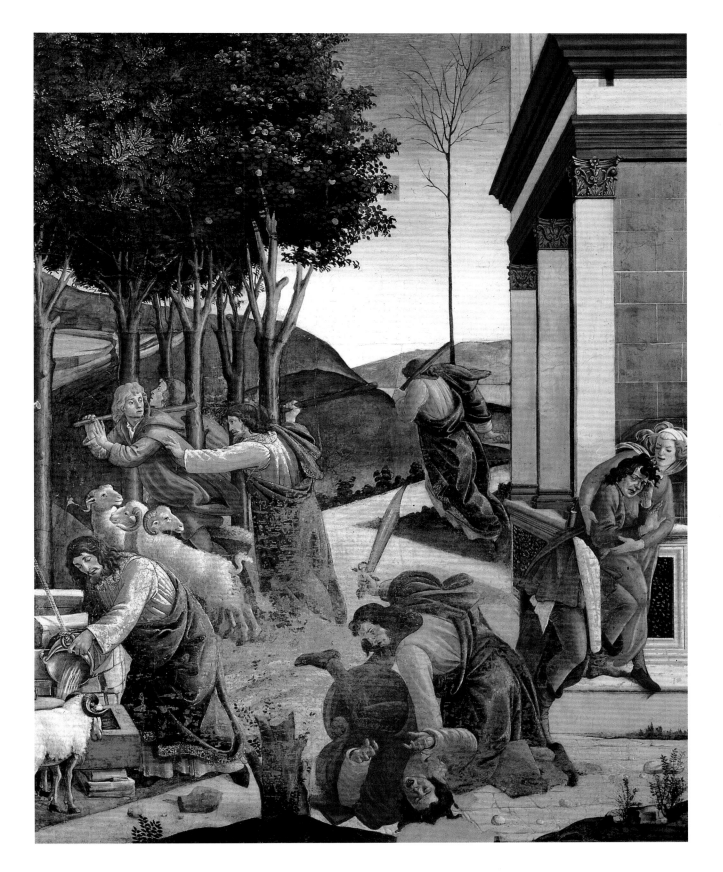

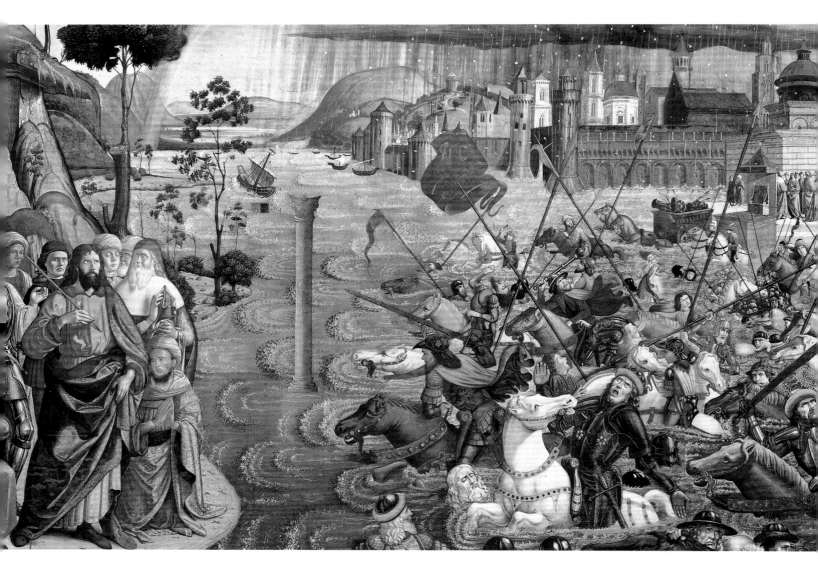

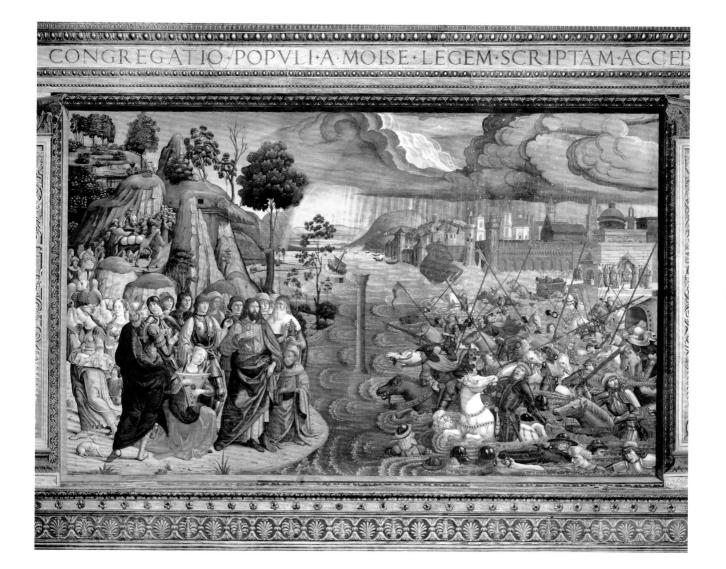

Biagio d'Antonio, *Crossing of the Red Sea*

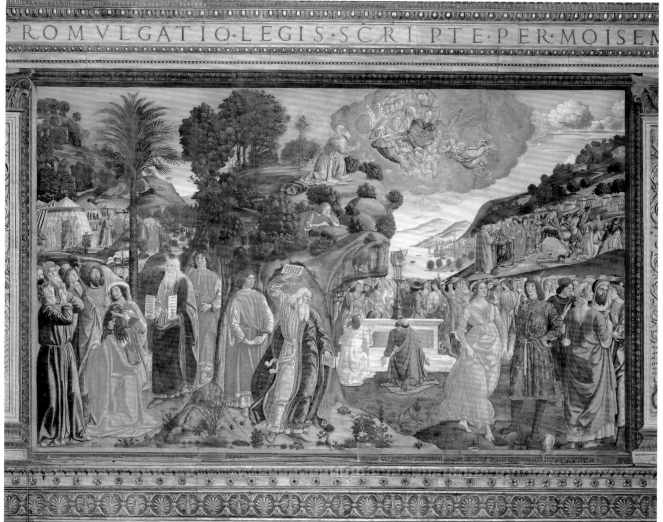

Cosimo Rosselli, *Moses receiving the Tablets of the Law*

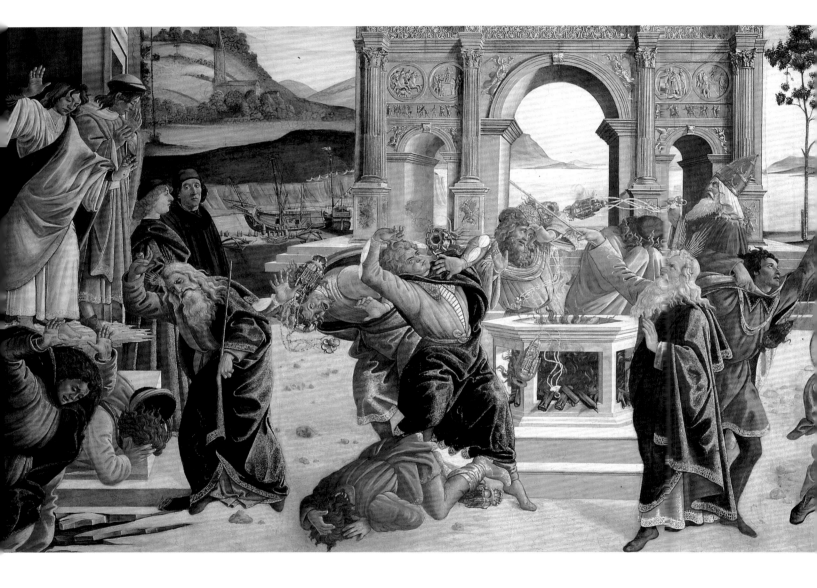

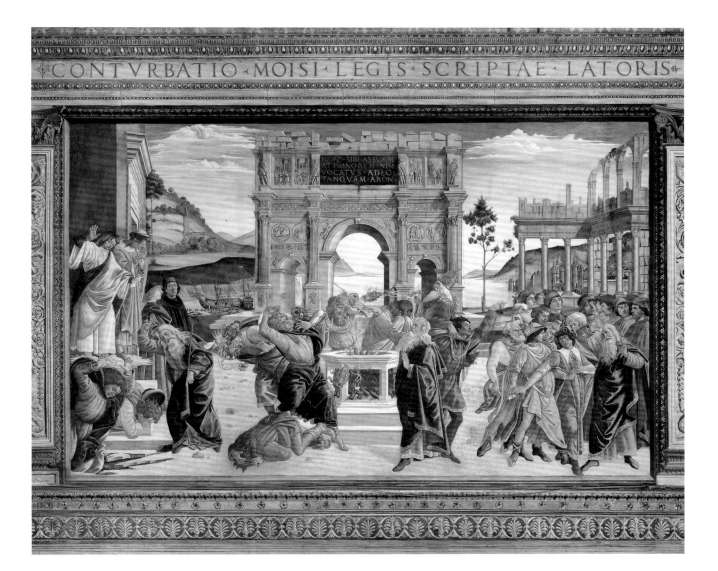

Sandro Botticelli, *Punishment of Korah, Dathan and Abiram*

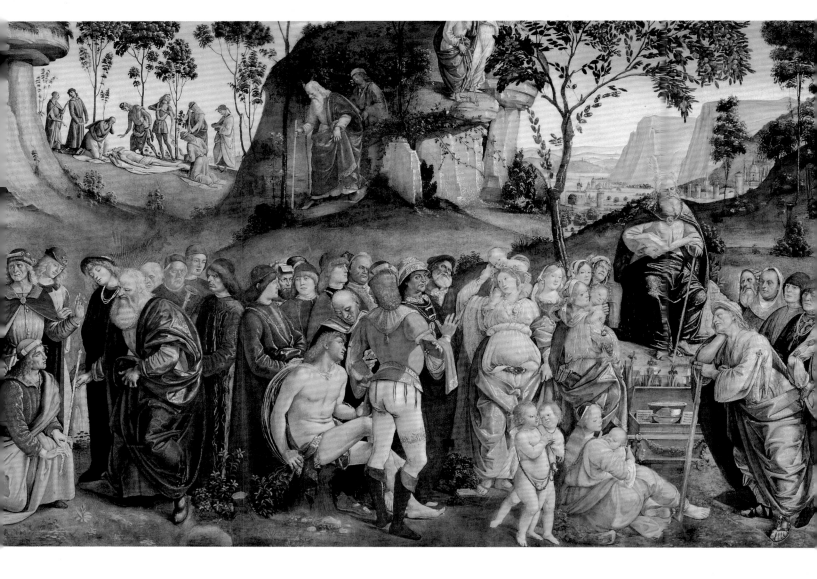

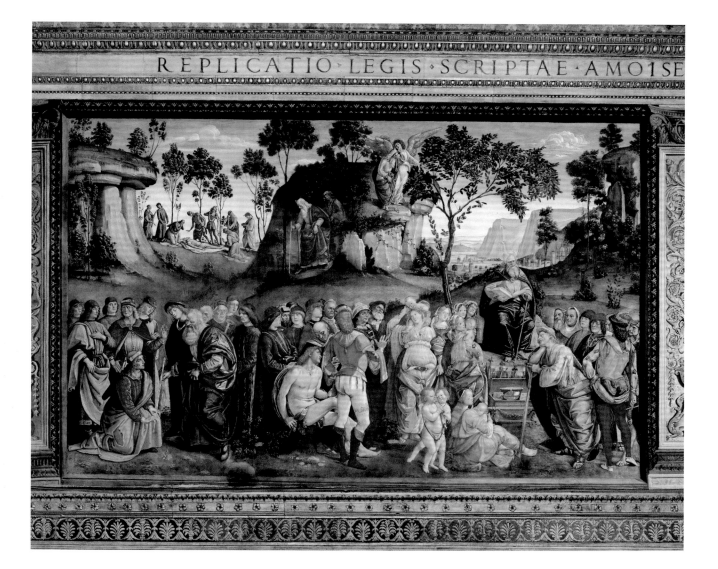

Luca Signorelli and Bartolomeo della Gatta, *Testament of Moses*

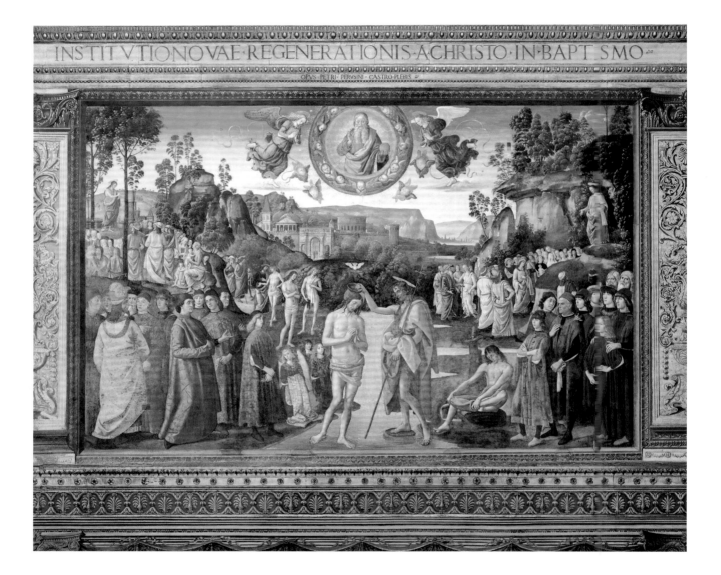

Pietro Perugino, *Baptism of Christ*

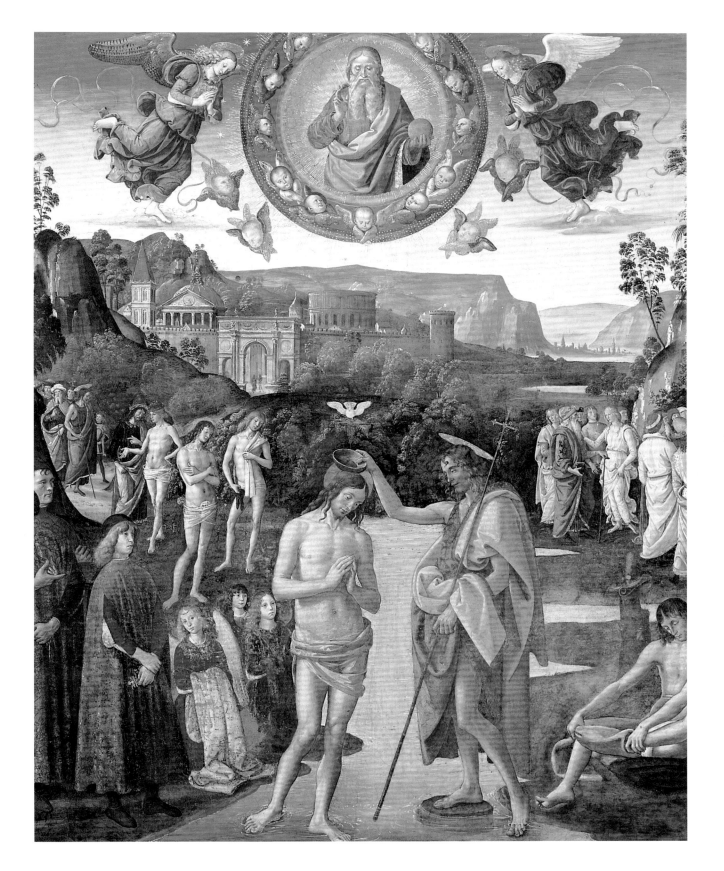

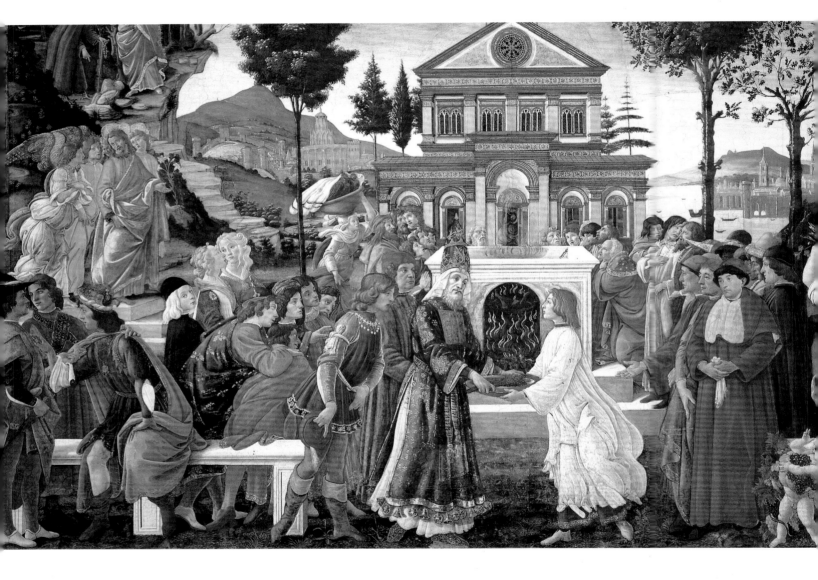

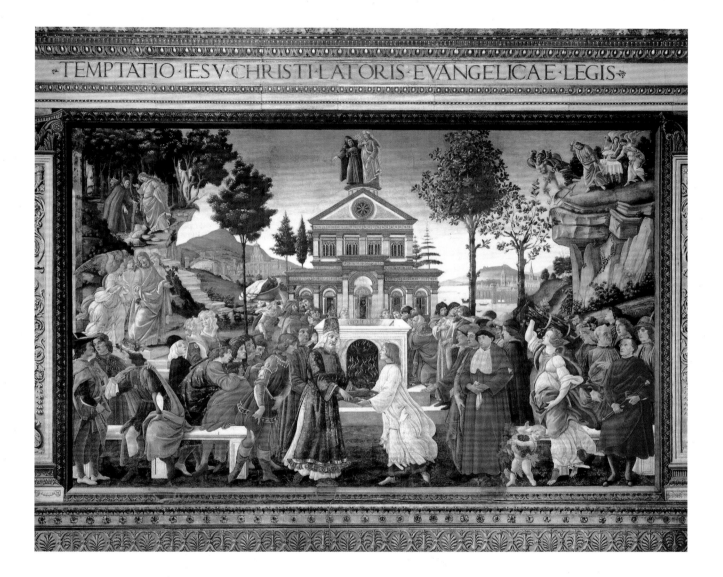

Sandro Botticelli, *Temptations of Christ*

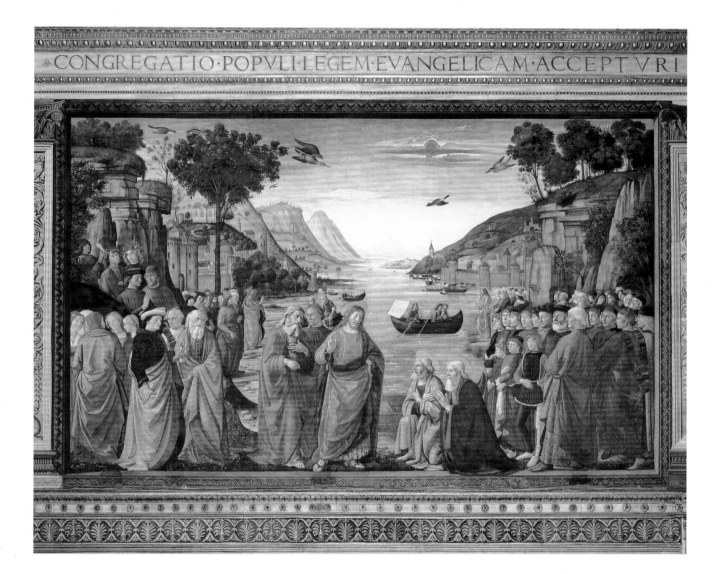

Domenico Ghirlandaio, *Vocation of the First Apostles*

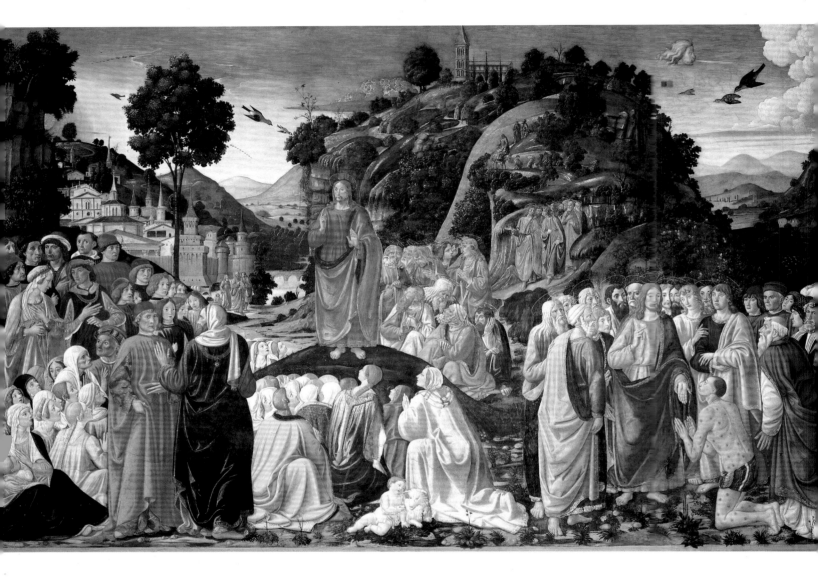

Cosimo Rosselli, *Sermon on the Mount*

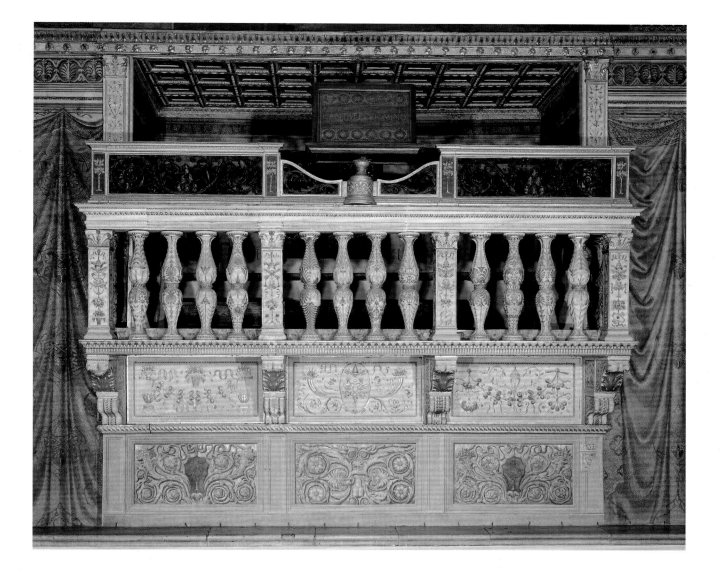

Mino da Fiesole, Choir

On the following pages:
Sistine Chapel, Wall with False Drapes

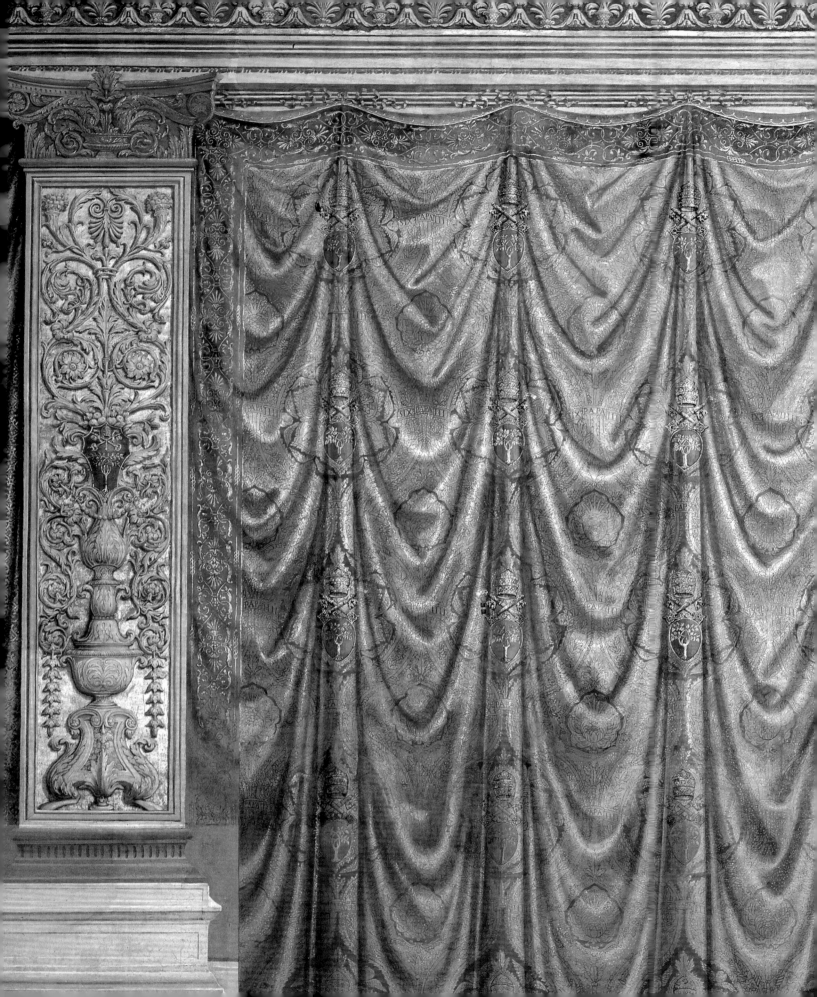

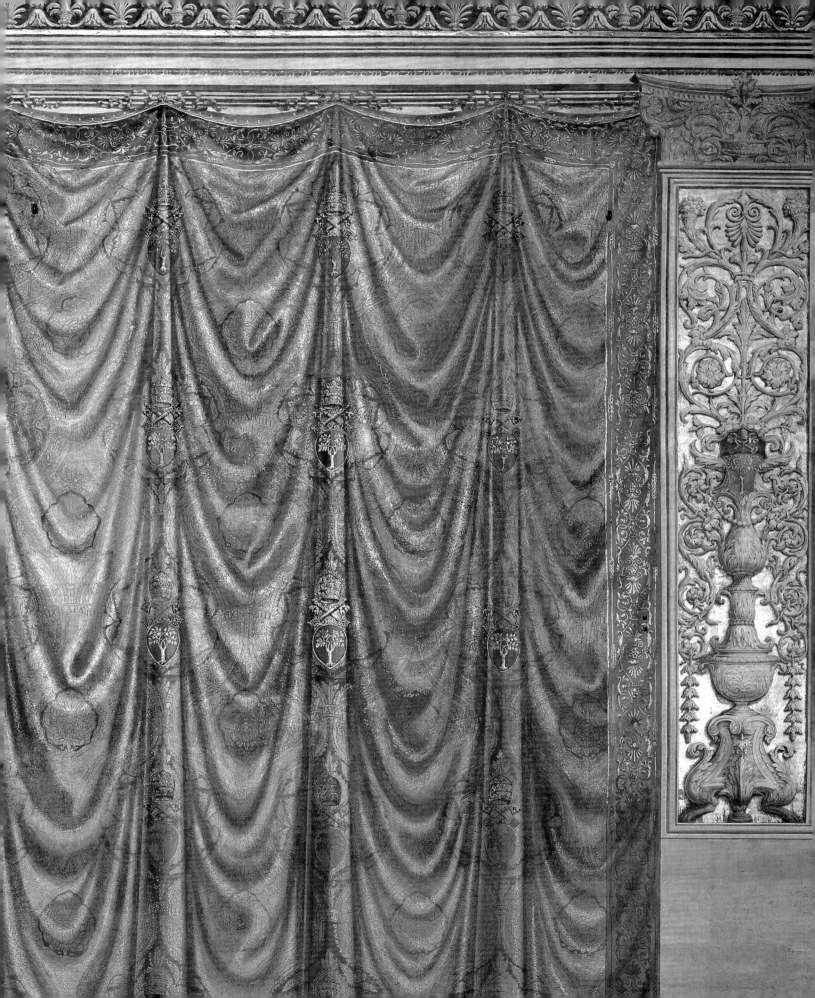

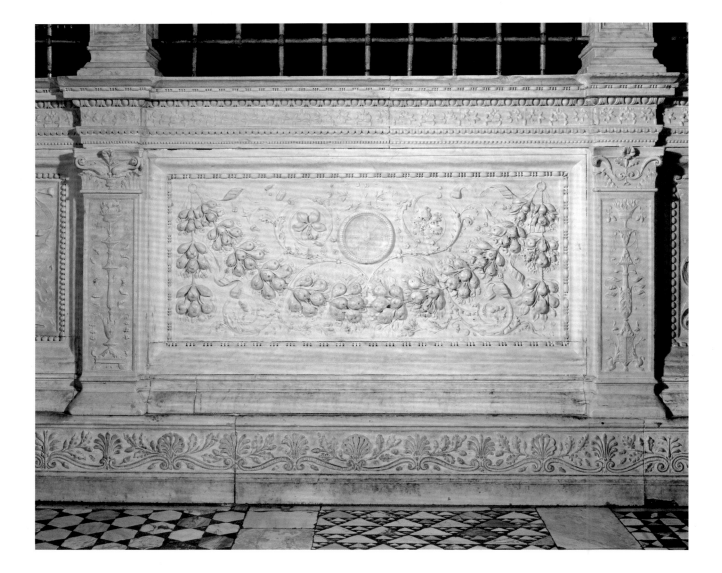

Mino da Fiesole and assistants, Sections of the Presbyterial Screen

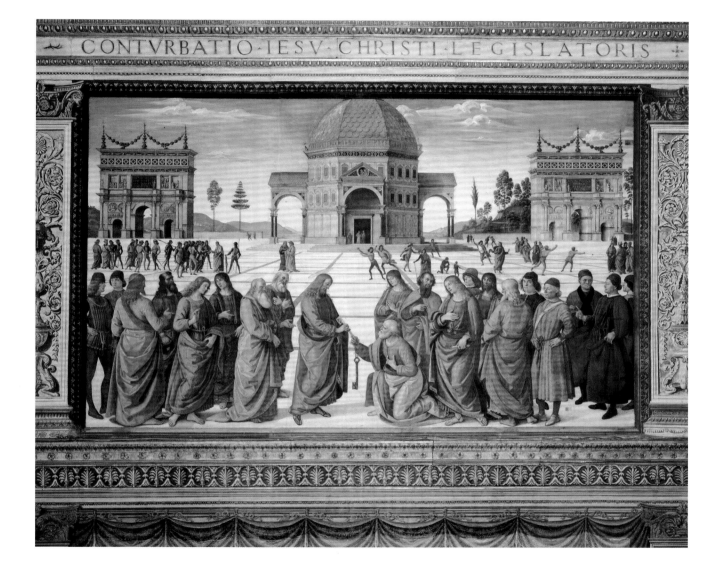

Pietro Perugino, *Consignment of the Keys to St. Peter*

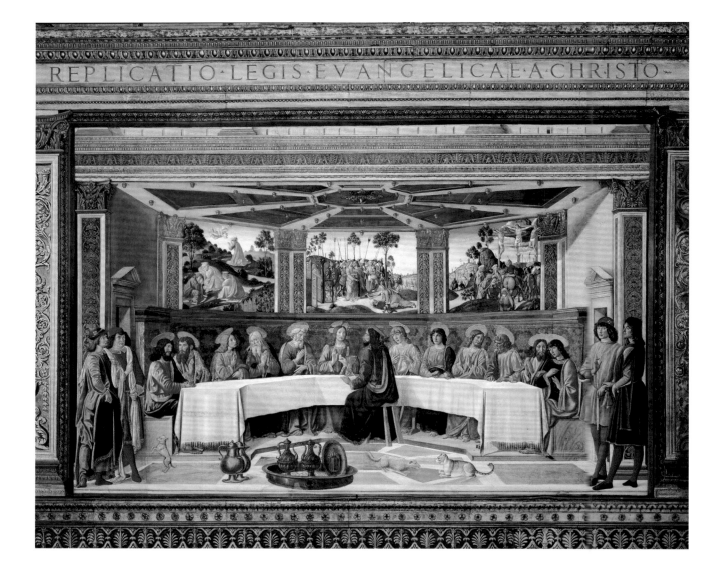

Cosimo Rosselli and Biagio d'Antonio, *Last Supper*

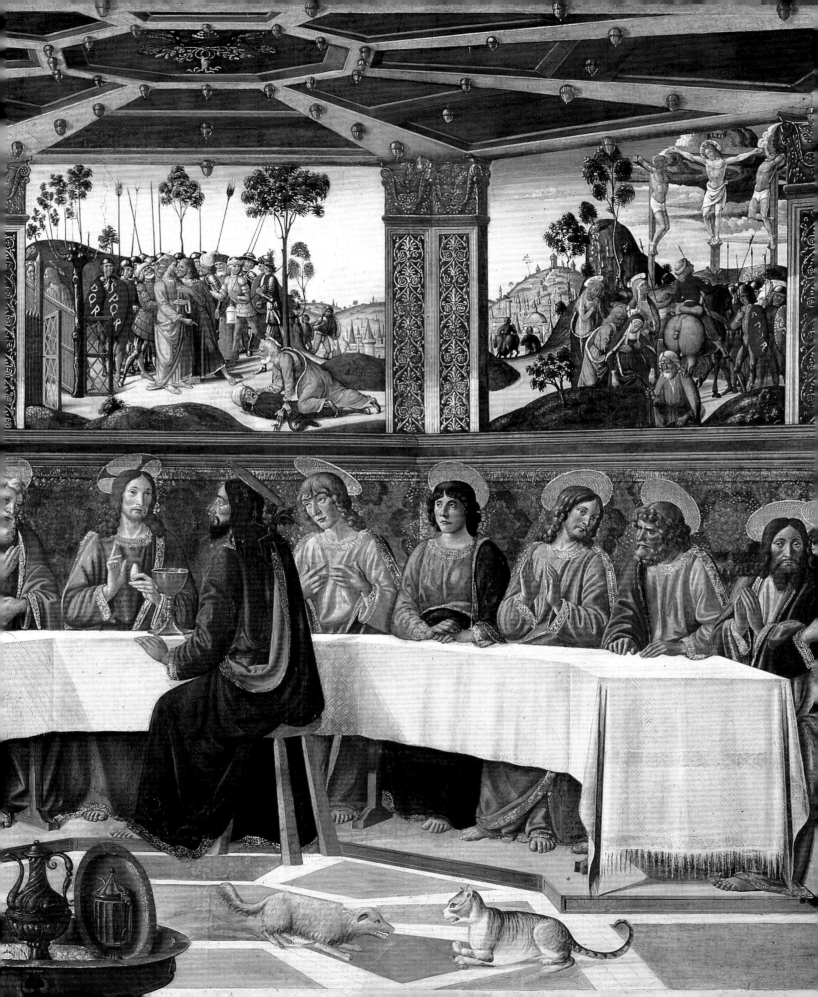

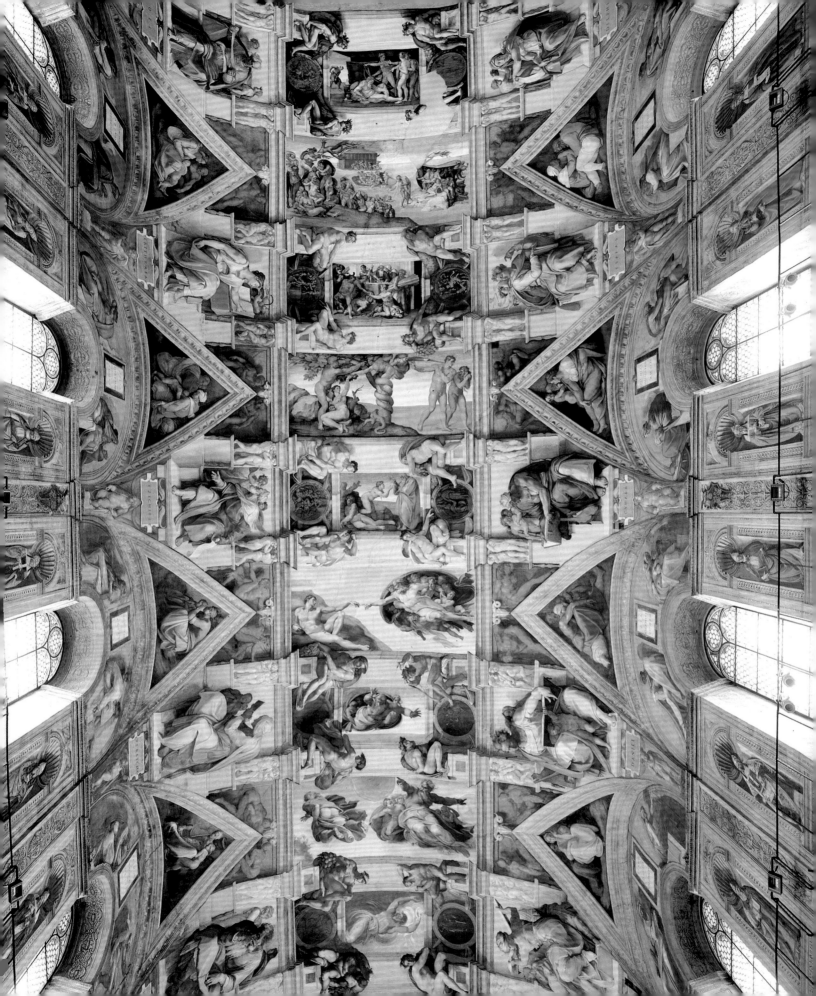

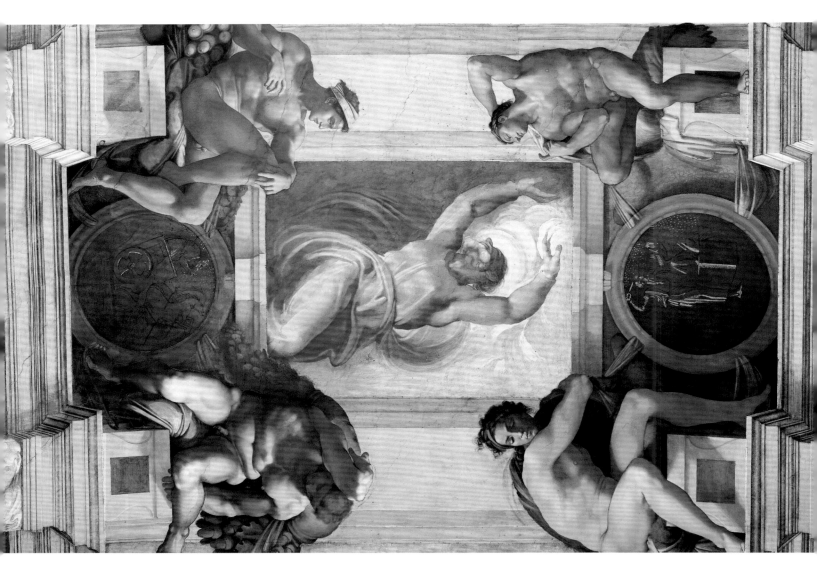

On the previous page:
Ceiling of the Sistine Chapel

On these pages:
Michelangelo, *Separation of Light and Darkness*

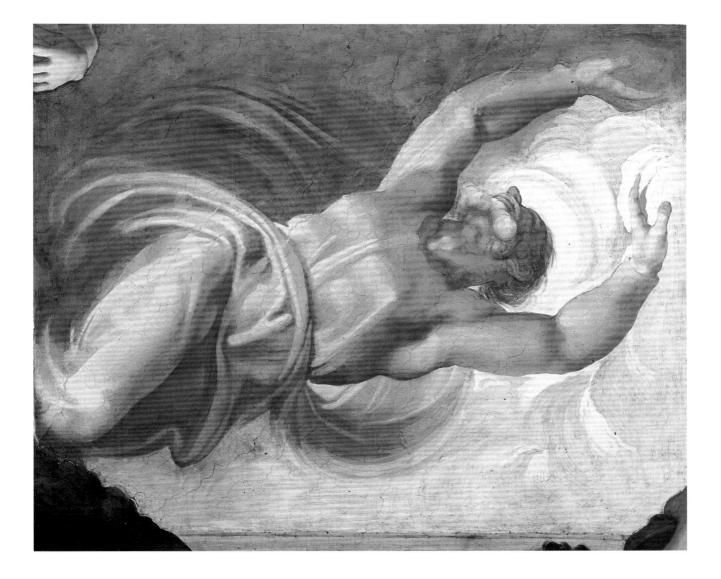

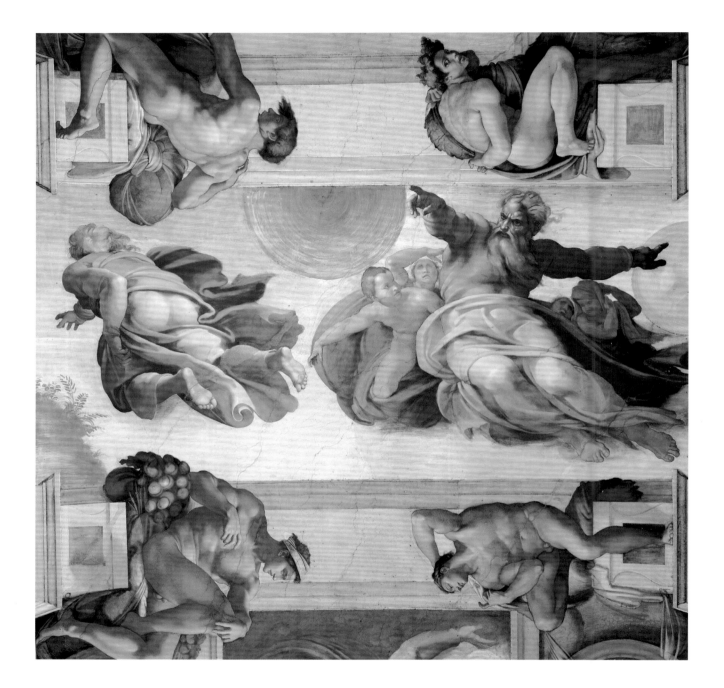

Michelangelo, *Creation of the Sun, the Moon and the Plants*

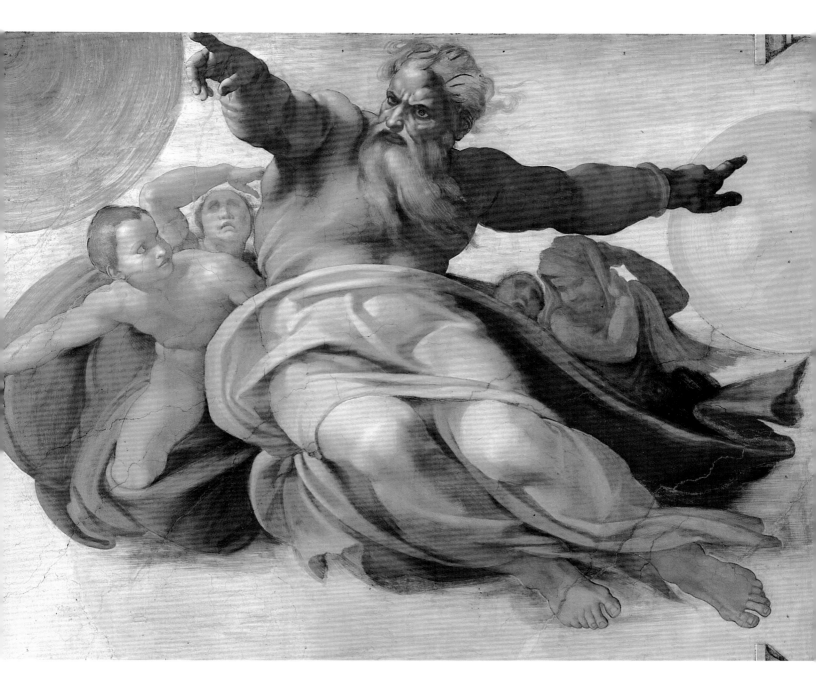

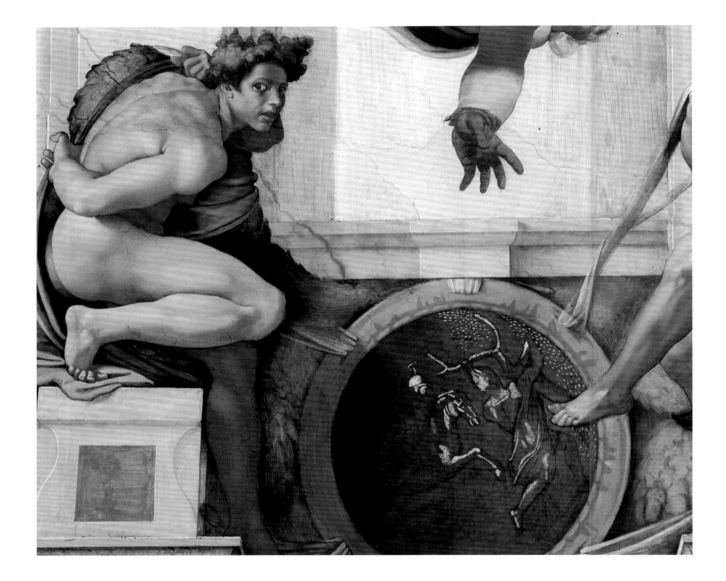

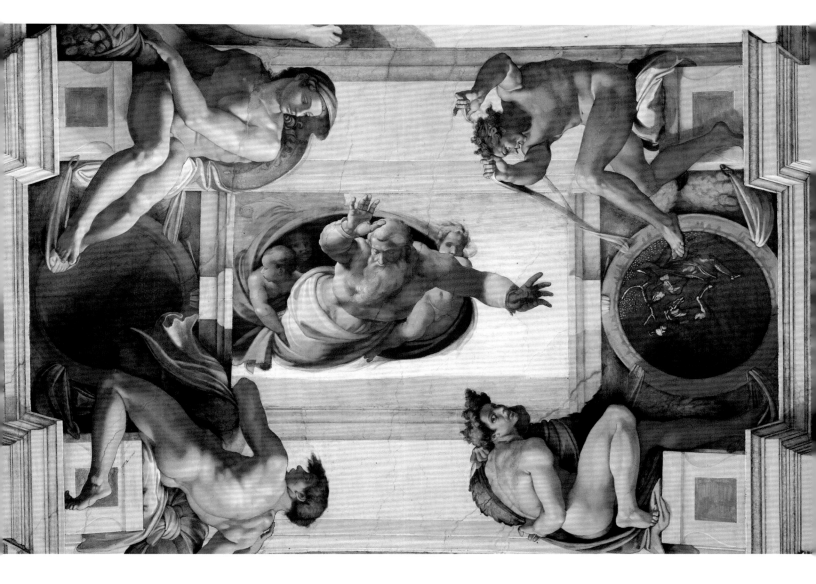

Michelangelo, *Separation of Land from Water*

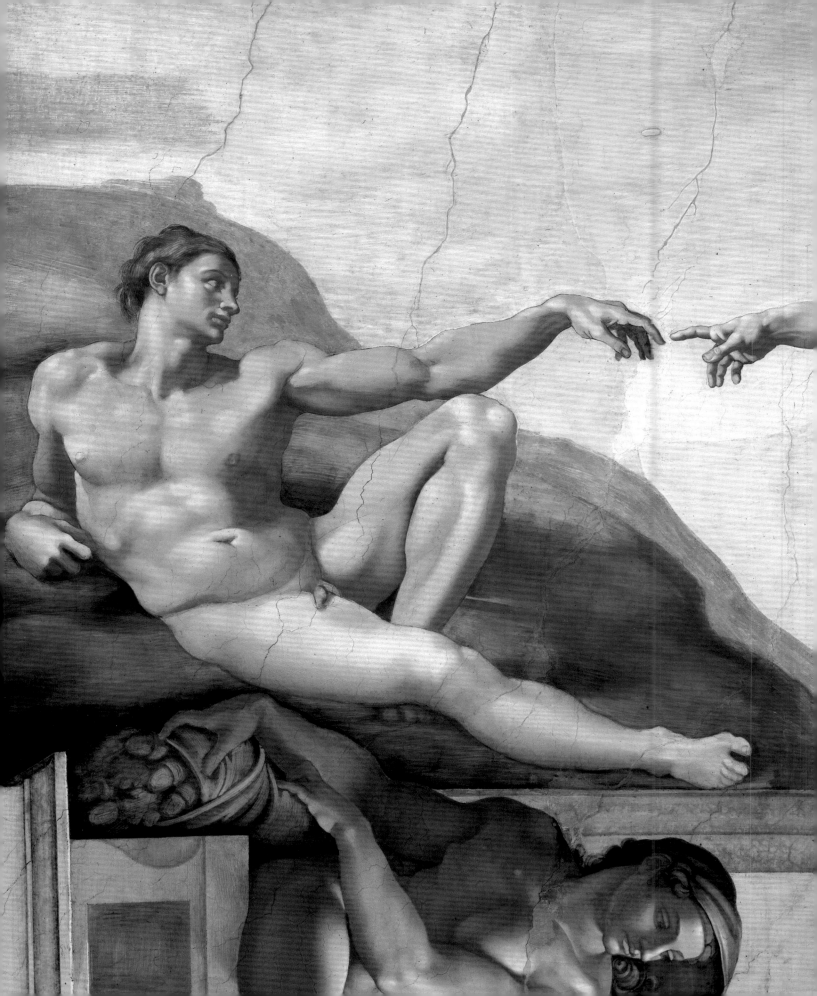

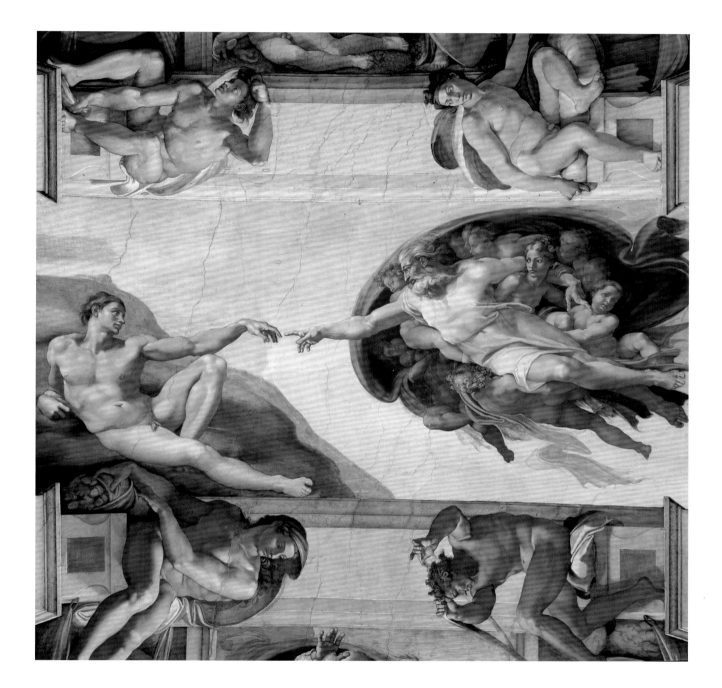

61

On these pages and the following pages:
Michelangelo, *Creation of Adam*

62

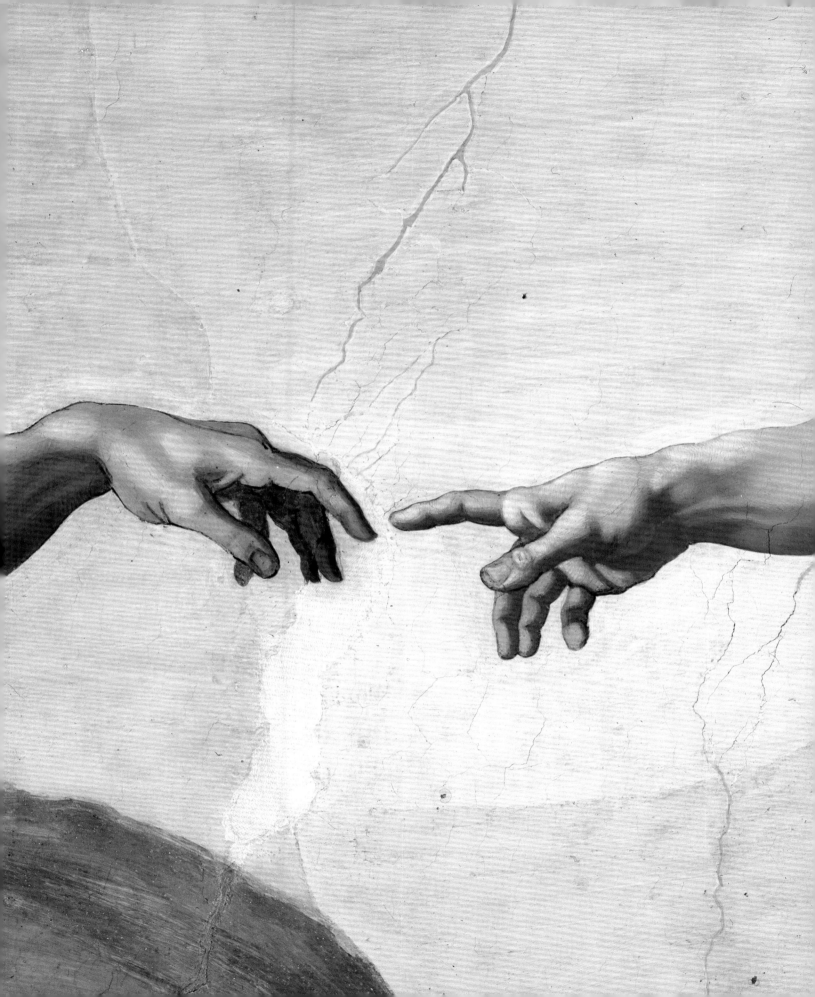

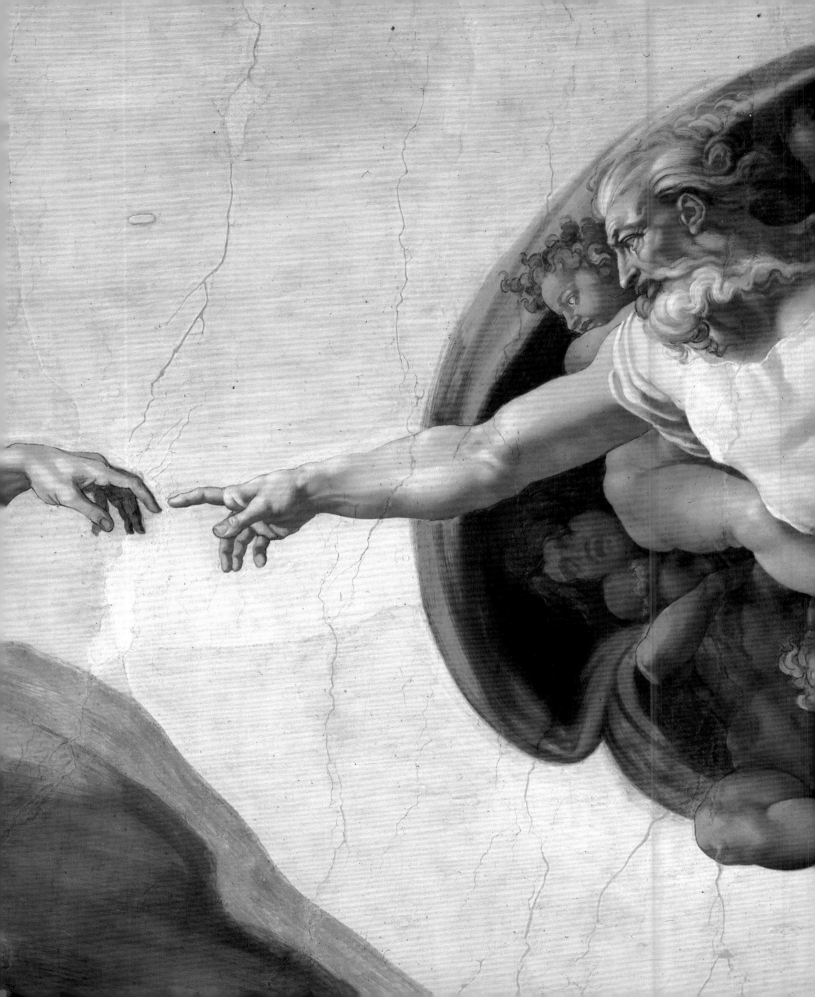

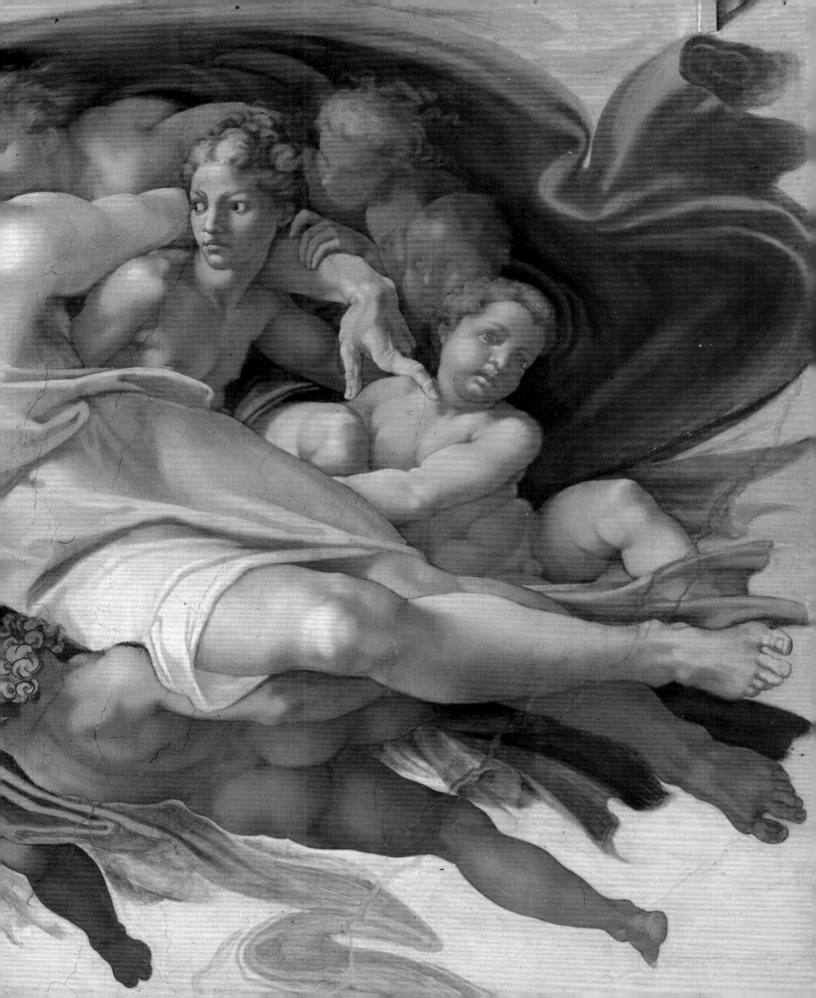

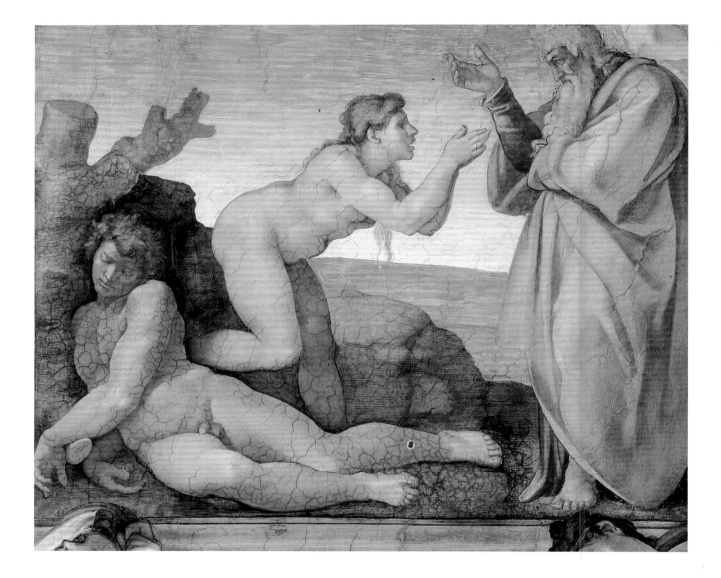

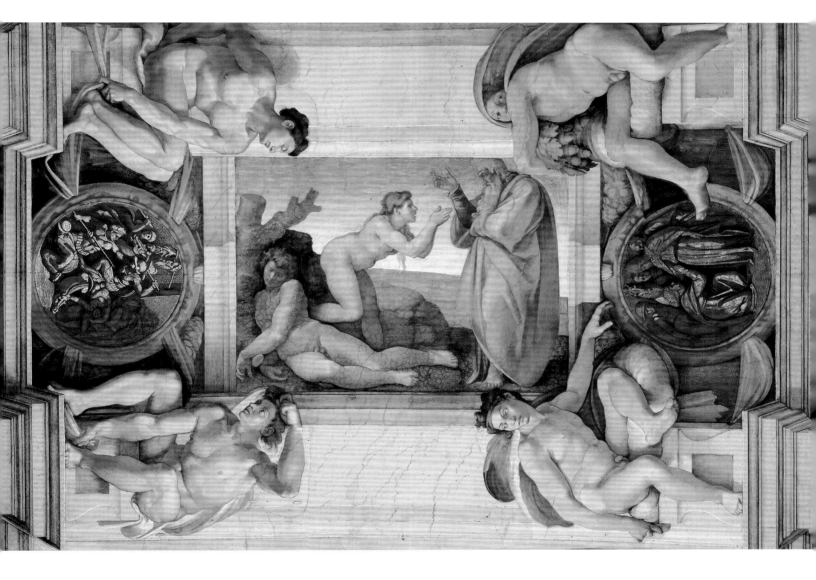

Michelangelo, *Creation of Eve*

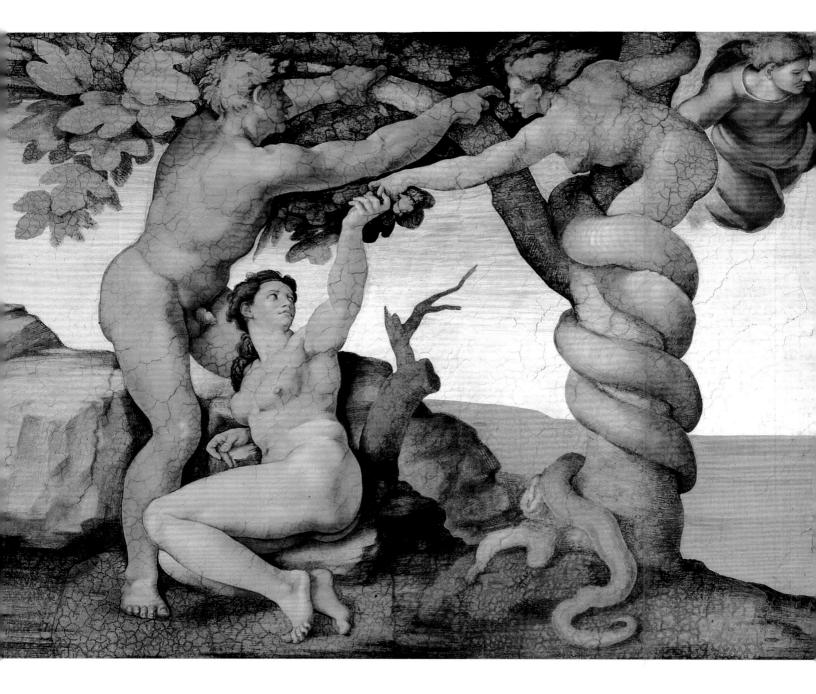

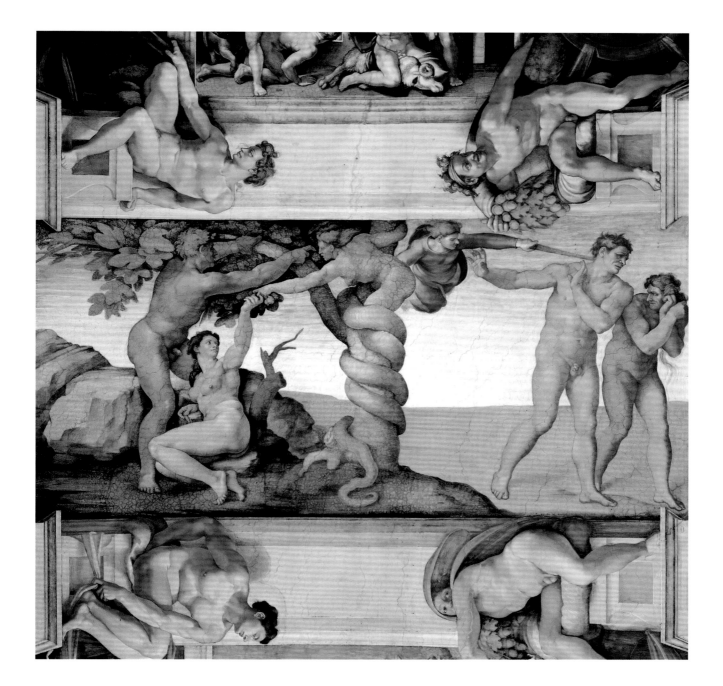

69

Michelangelo, *Original Sin and the Expulsion from Paradise*

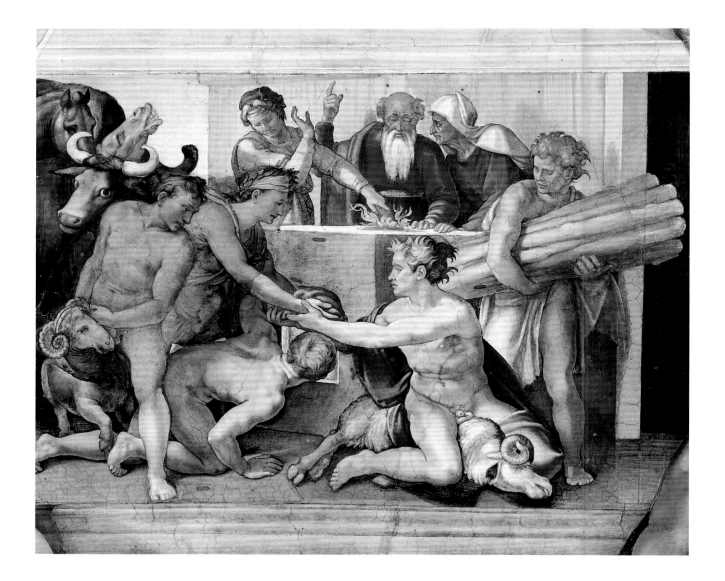

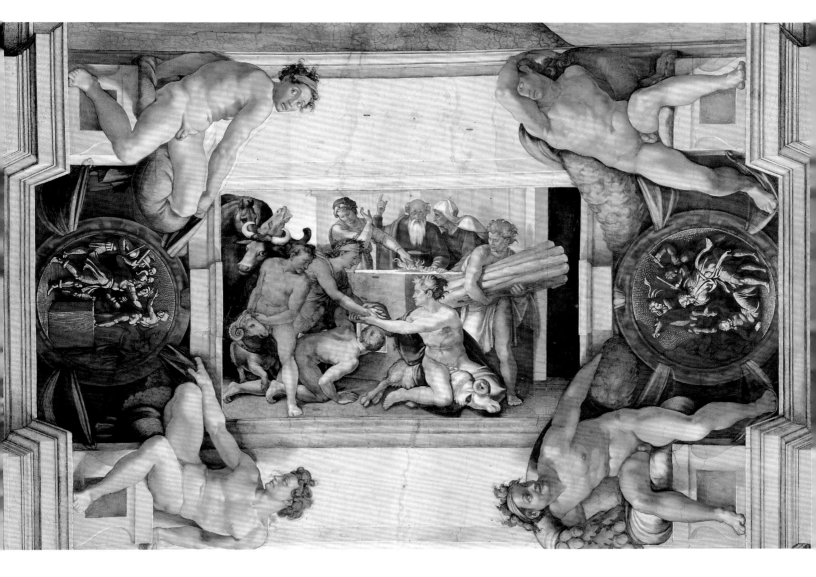

Michelangelo, *Noah's Sacrifice*

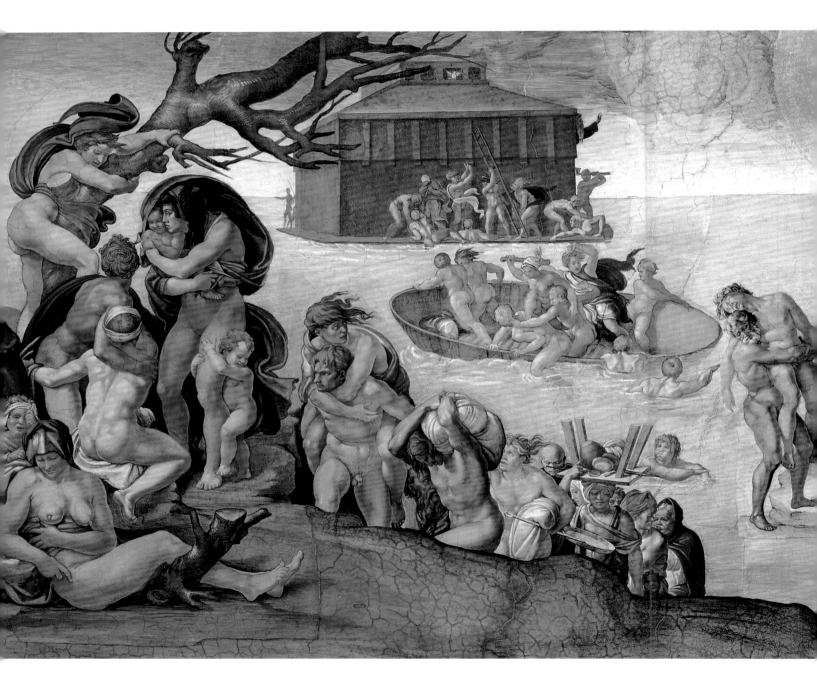

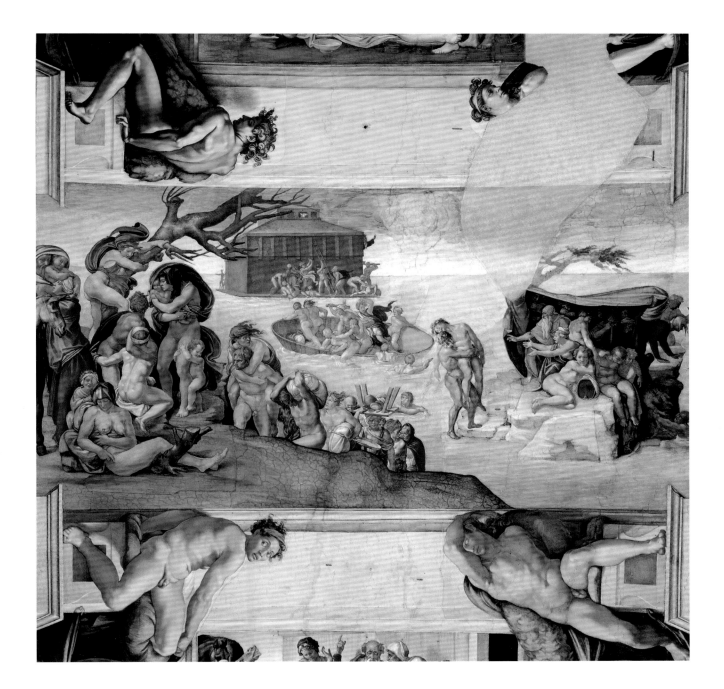

Michelangelo, *Flood*

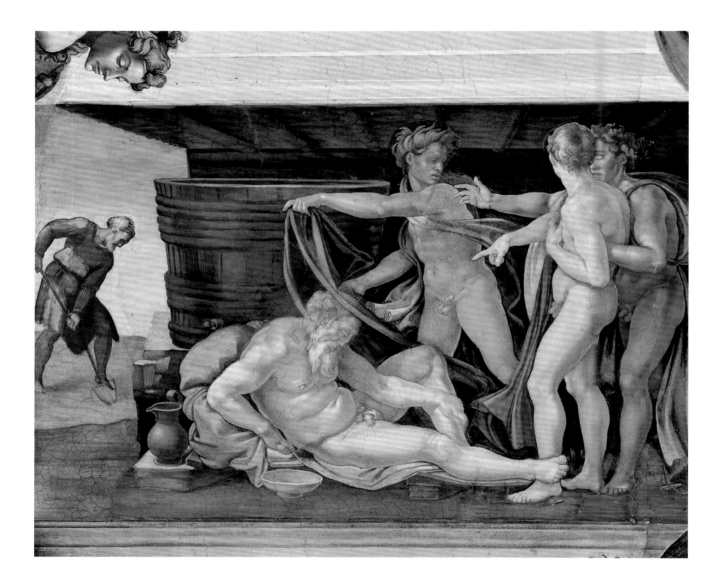

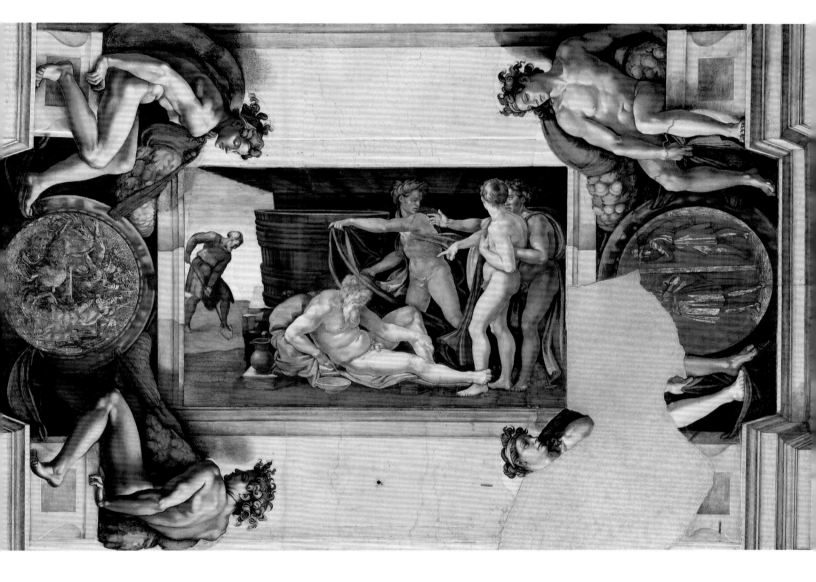

Michelangelo, *Drunkenness of Noah*

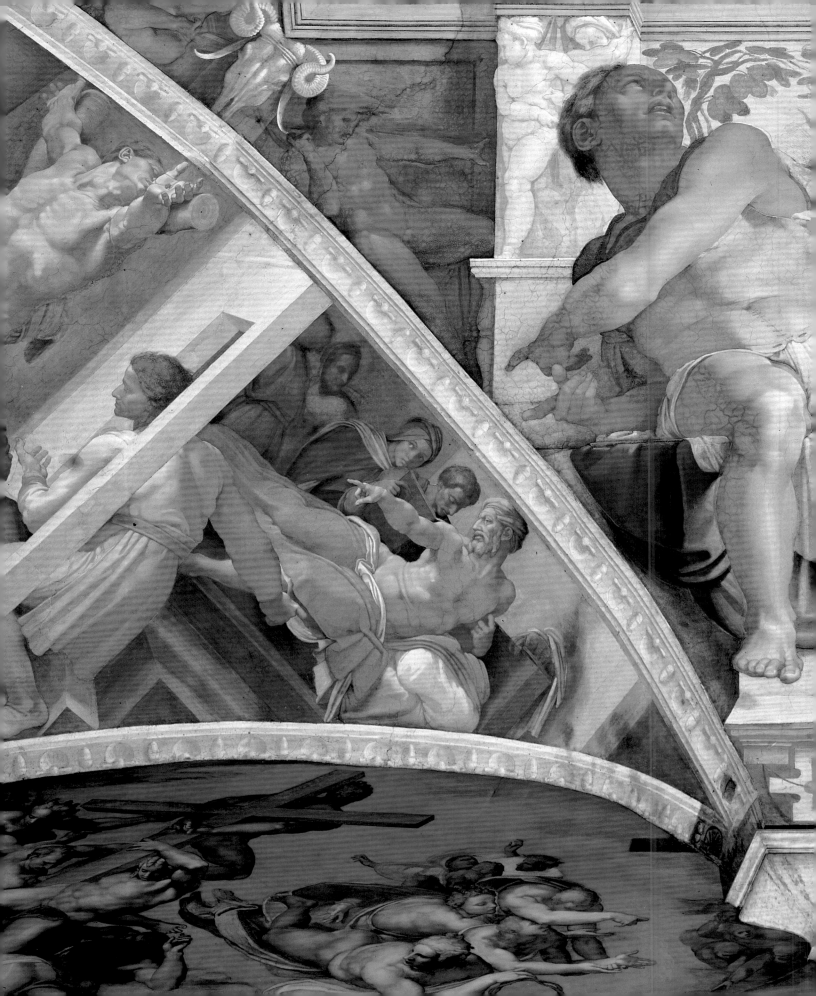

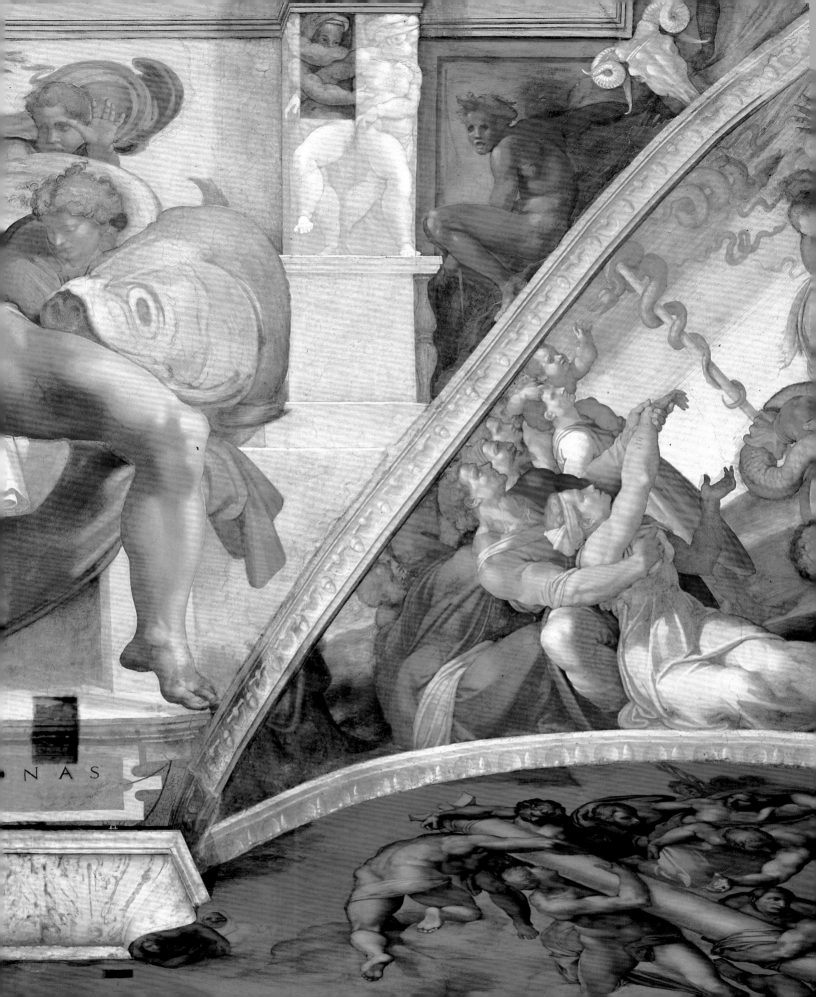

On the previous pages:
Michelangelo, *Prophet Jonah*

Michelangelo, *Libyan Sibyl*

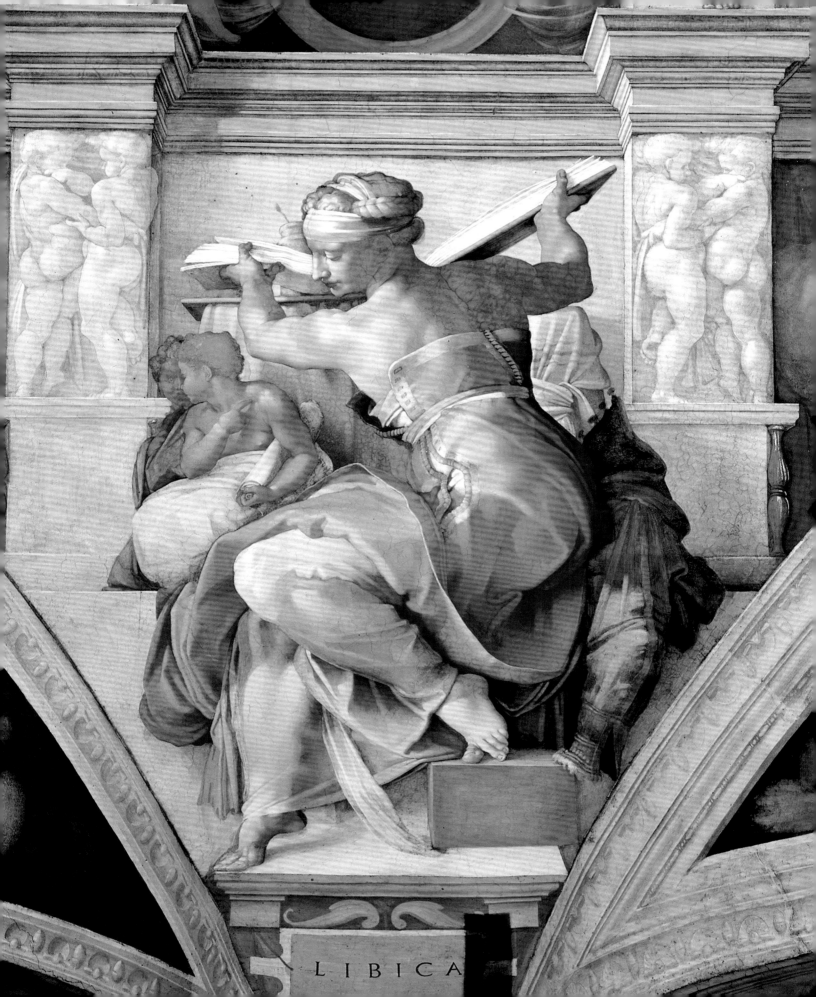

LIBICA

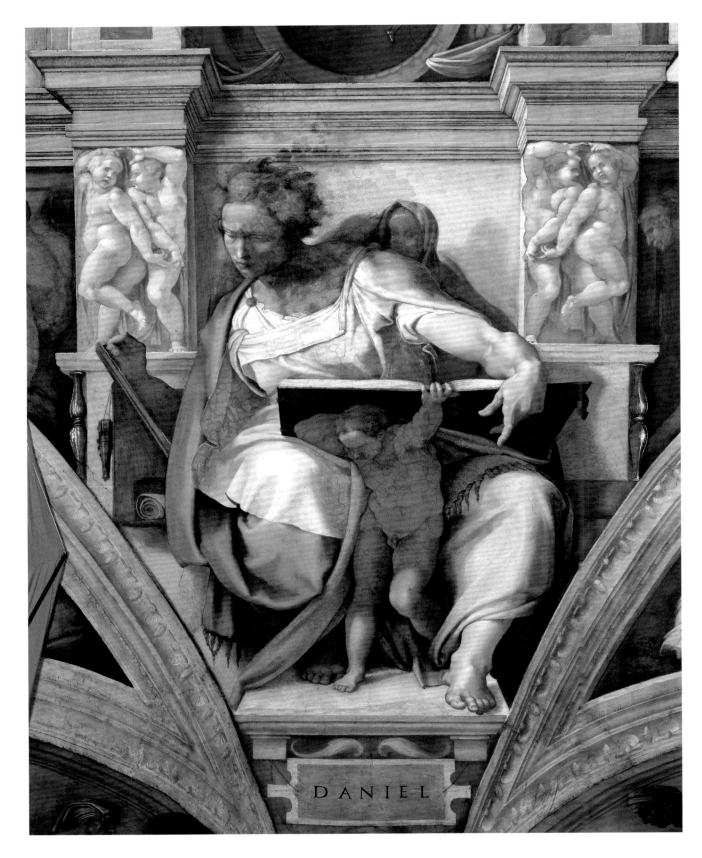

Michelangelo, *Prophet Daniel*

Michelangelo, *Cumaean Sibyl*

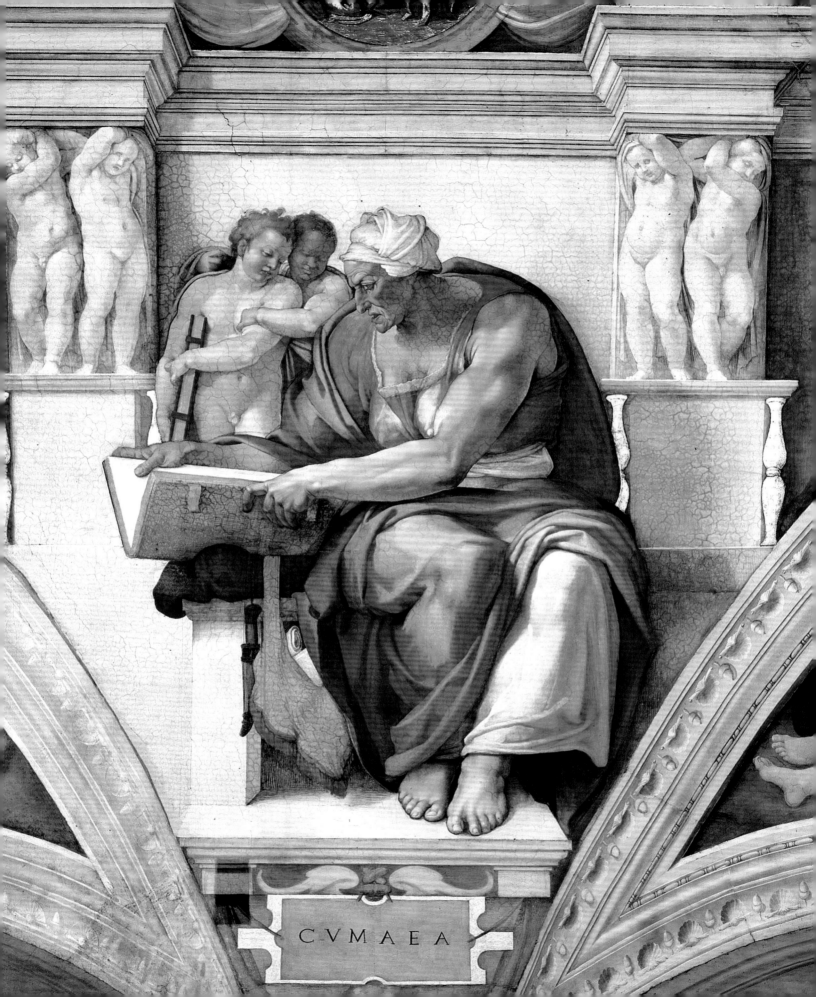

CVMAEA

Michelangelo, *Prophet Isaiah*

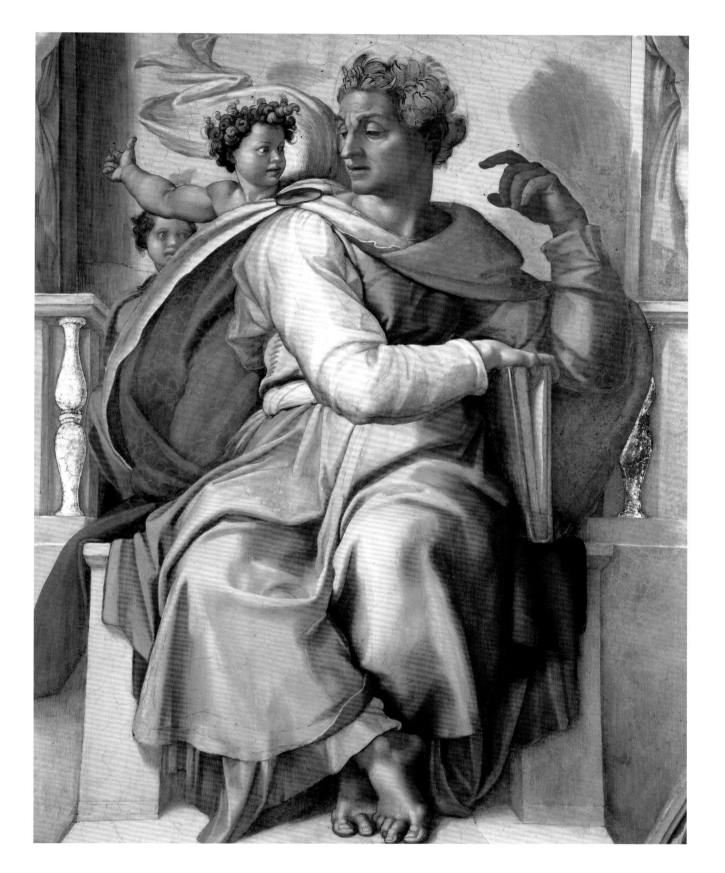

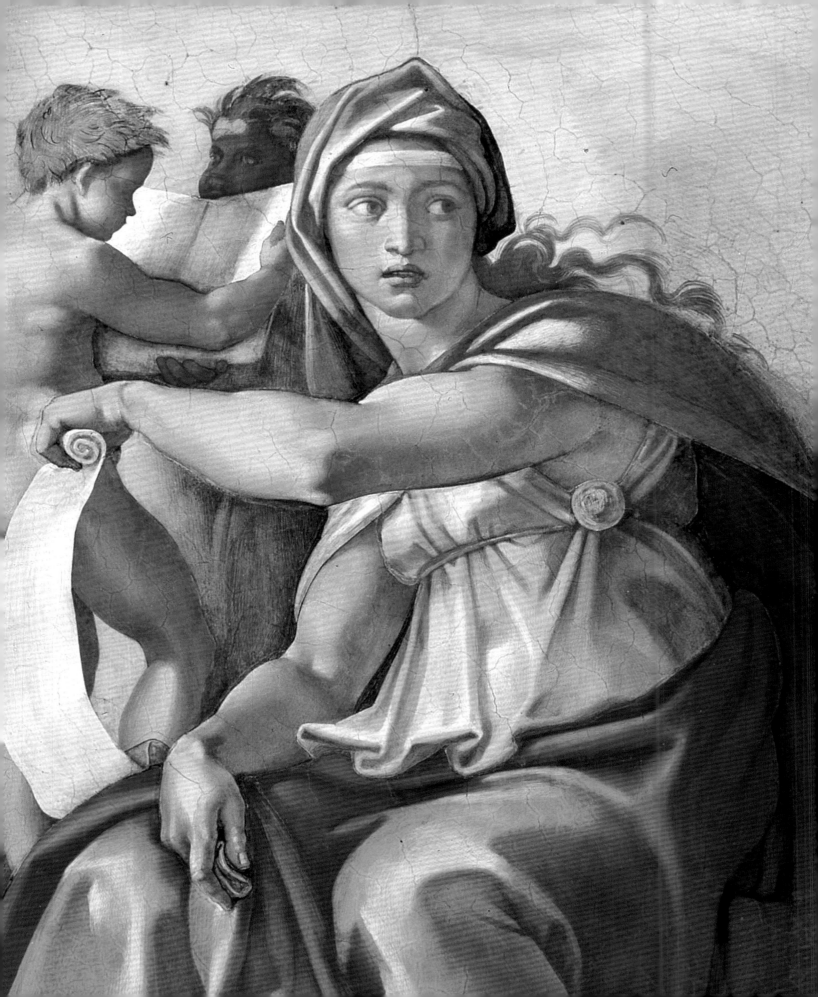

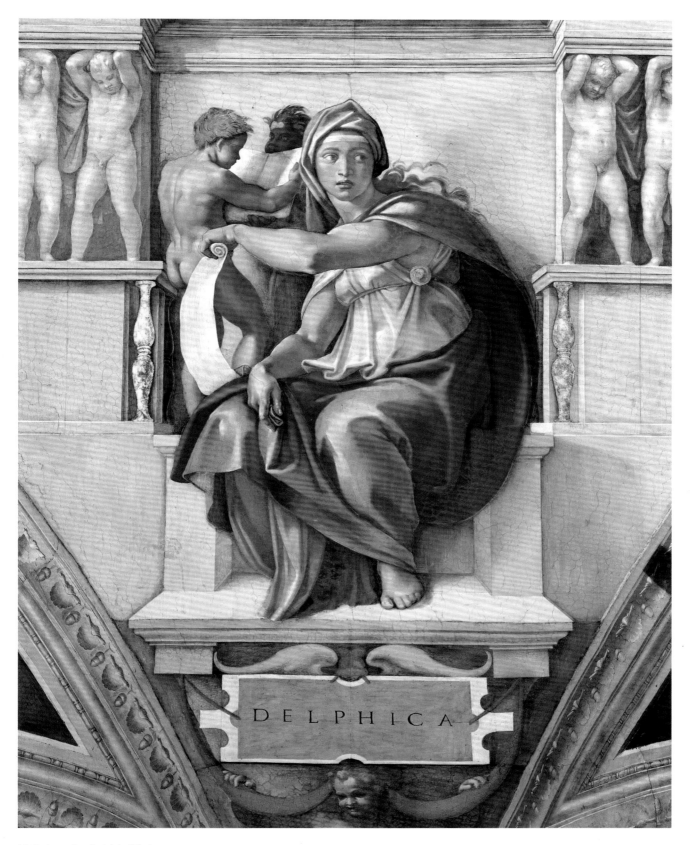

85

Michelangelo, *Delphic Sibyl*

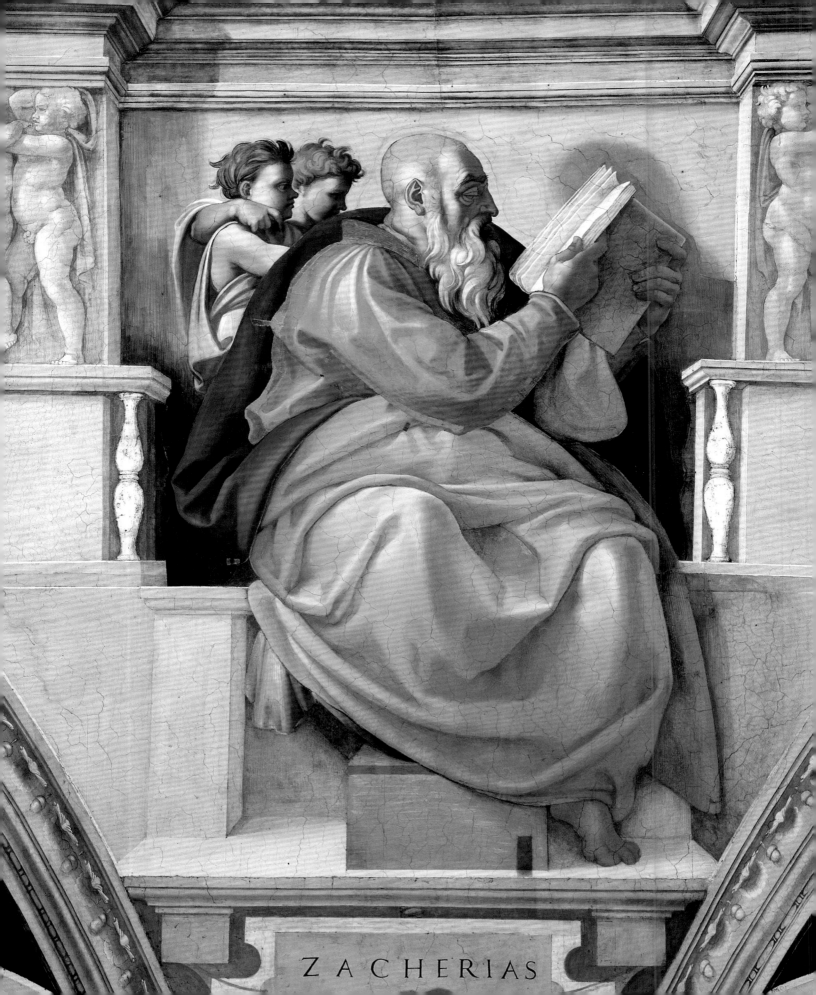

ZACHERIAS

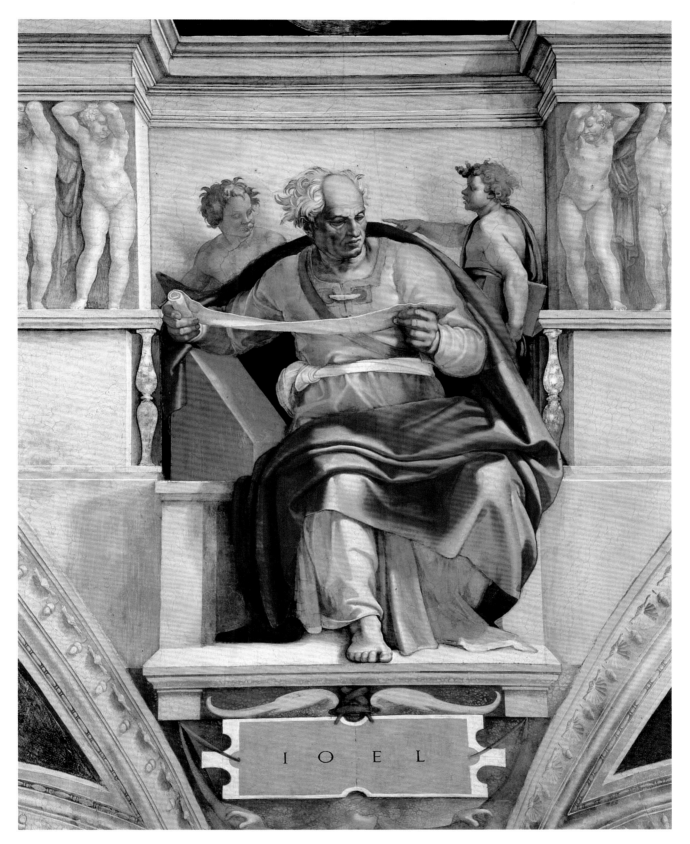

Michelangelo, *Prophet Zechariah*

Michelangelo, *Prophet Joel*

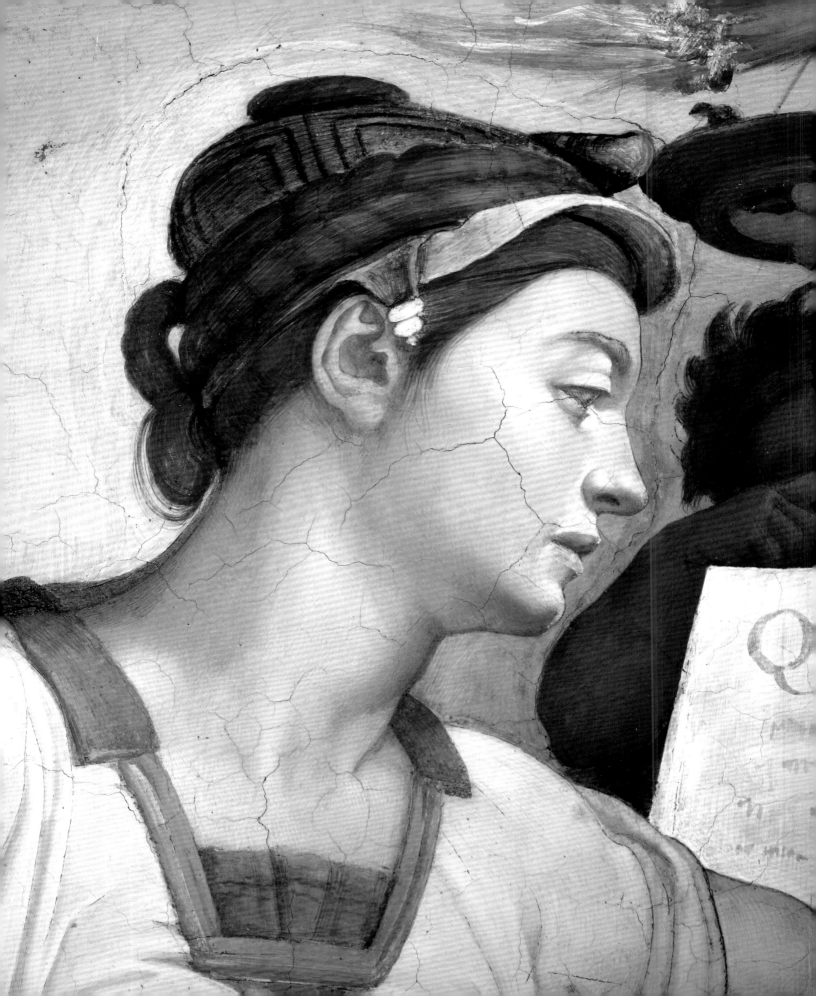

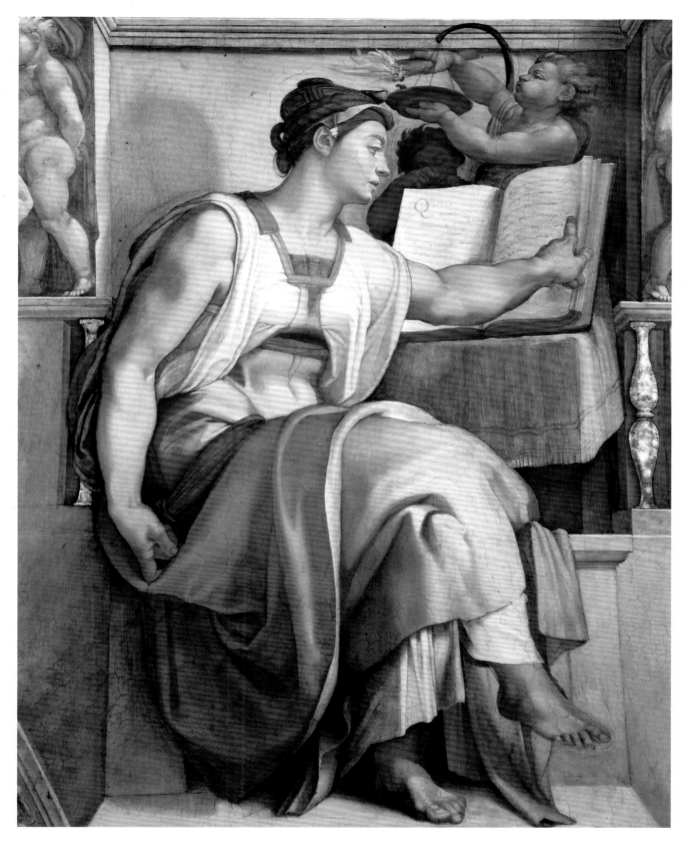

Michelangelo, *Erythrean Sibyl*

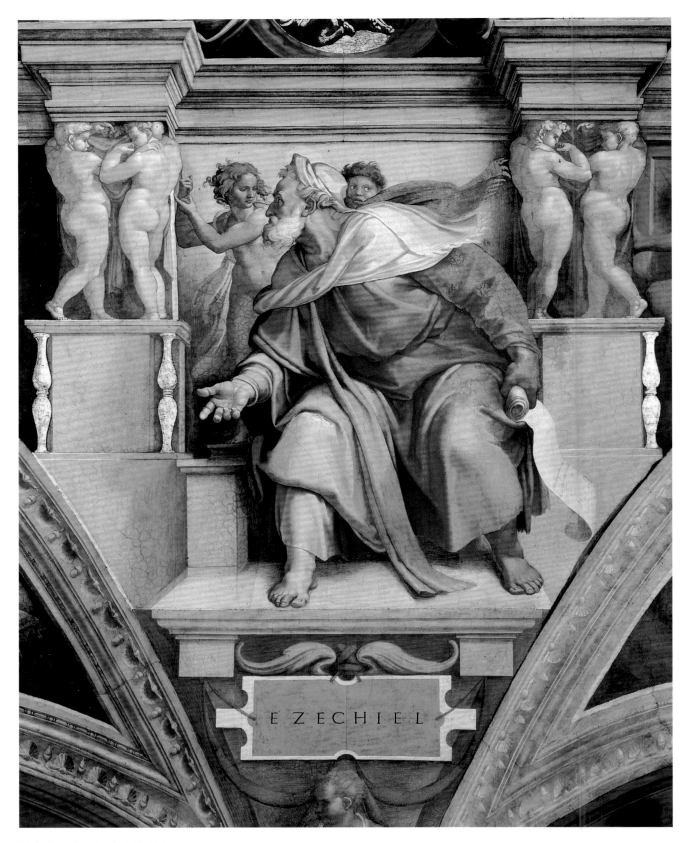

90

EZECHIEL

Michelangelo, *Prophet Ezekiel*

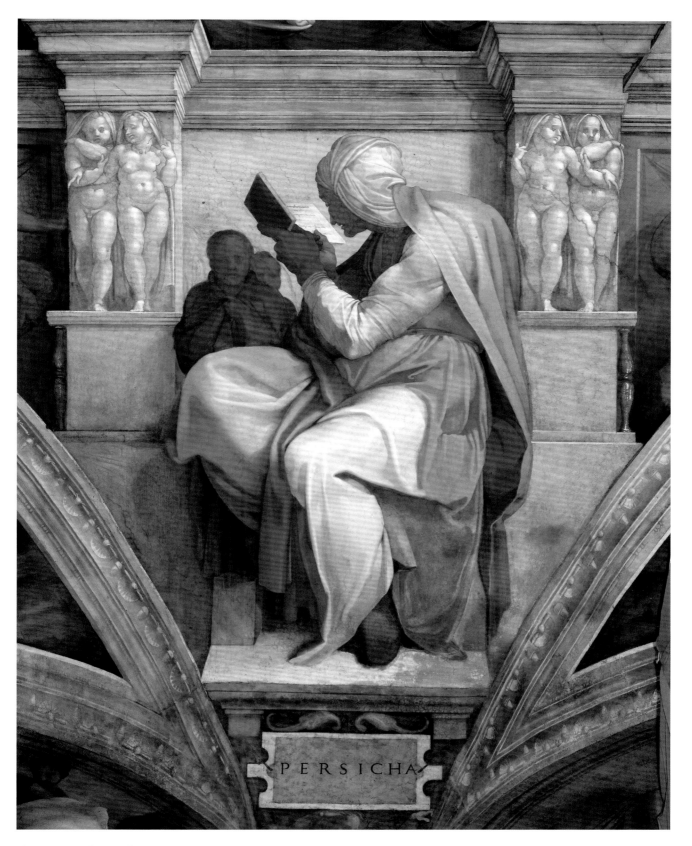

Michelangelo, *Persian Sibyl*

Michelangelo, *Prophet Jeremiah*

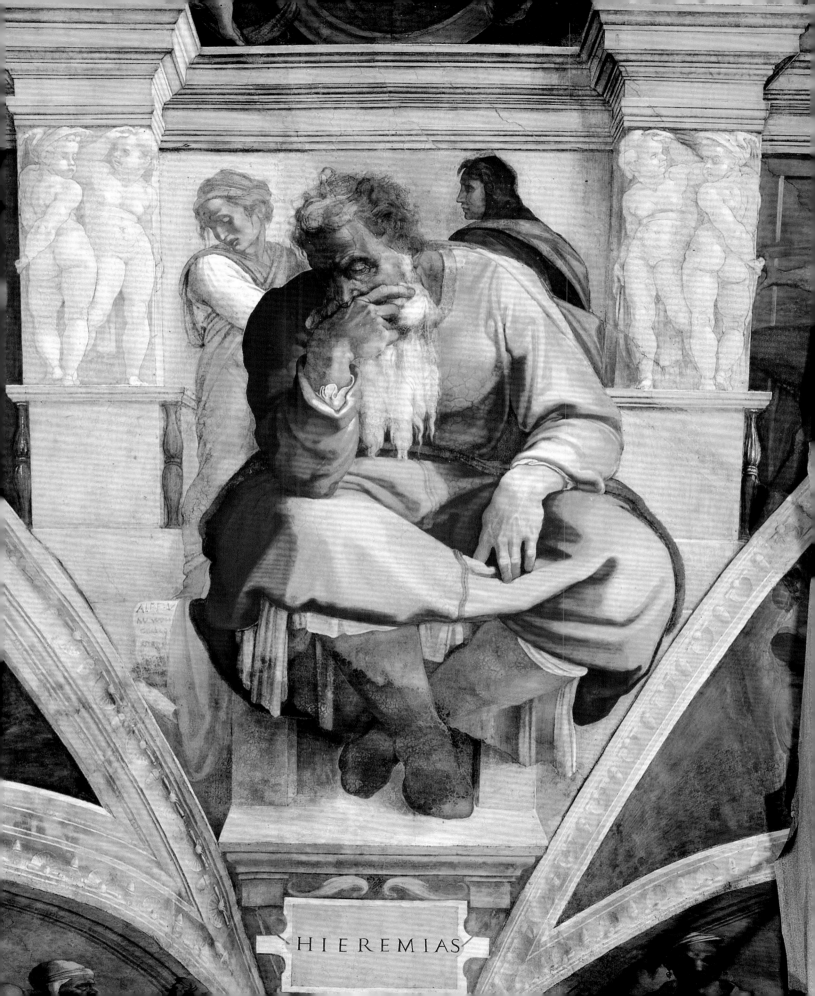

HIEREMIAS

Michelangelo, *Judith and Holofernes*

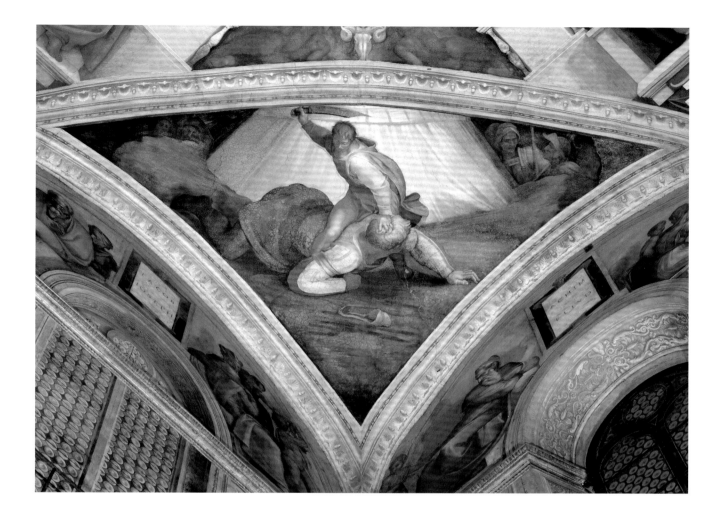

Michelangelo, *David and Goliath*

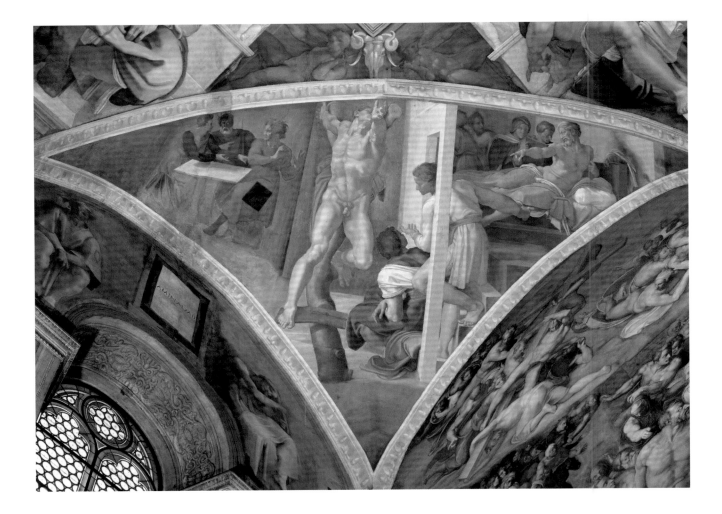

Michelangelo, *Punishment of Haman*

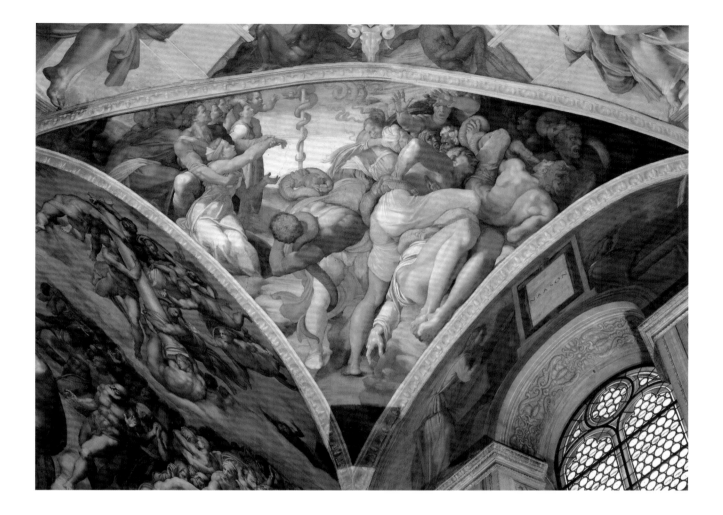

Michelangelo, *Bronze Serpent*

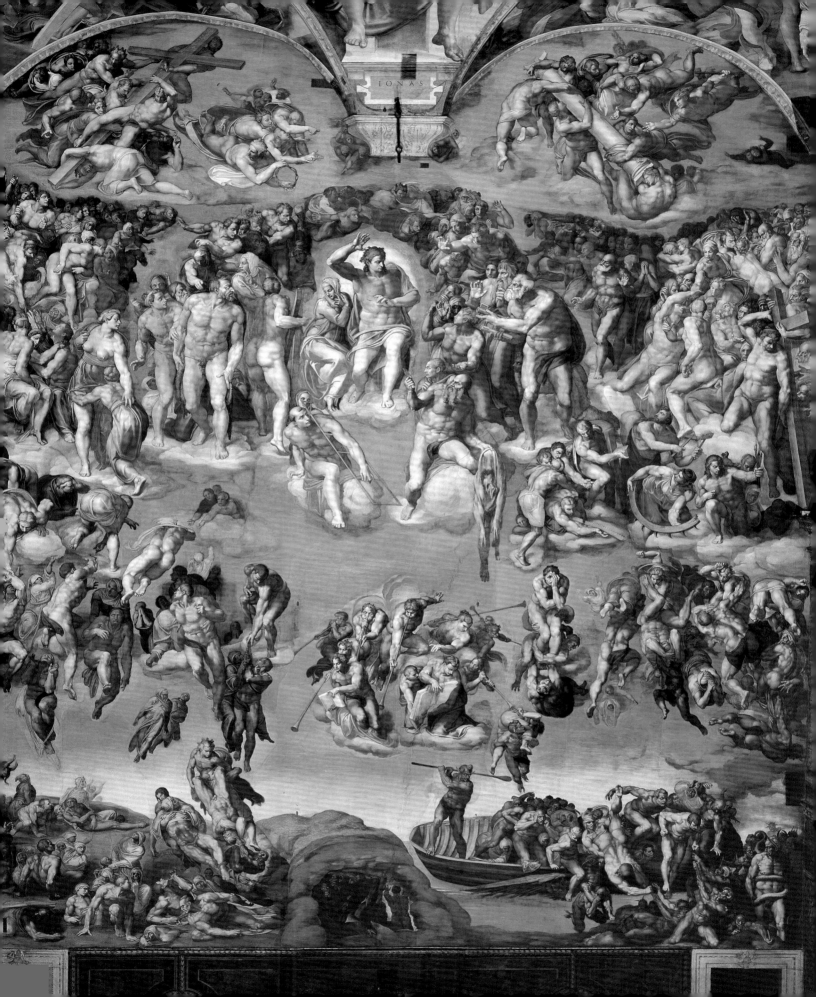

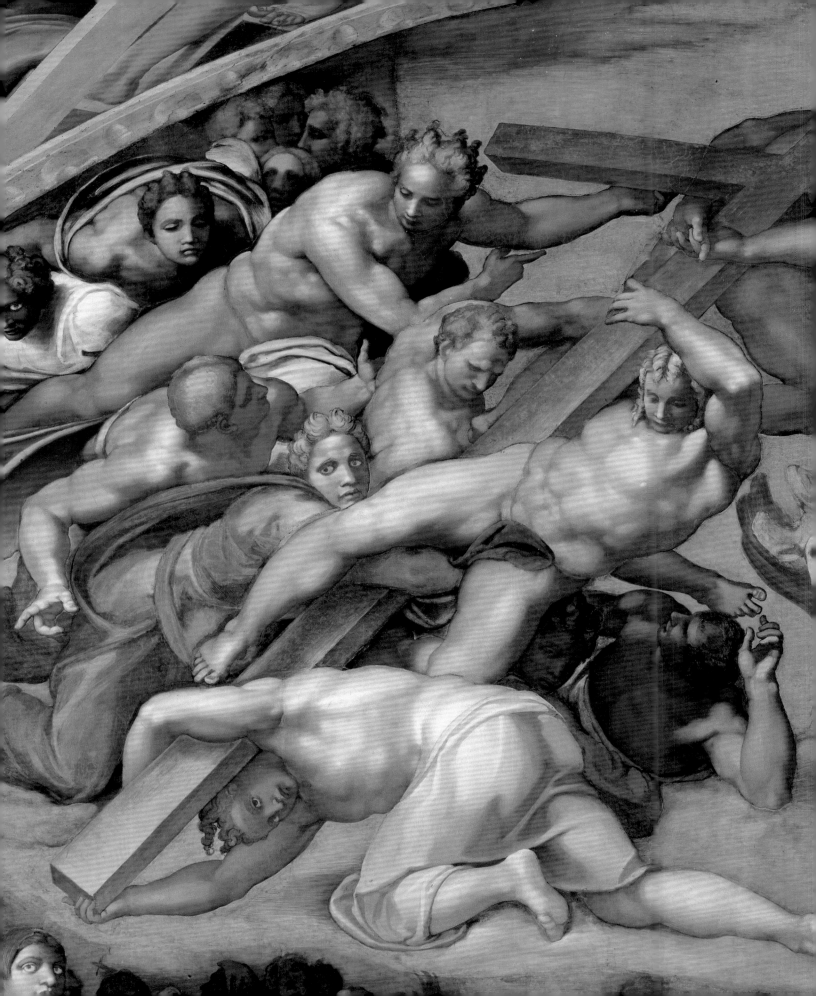

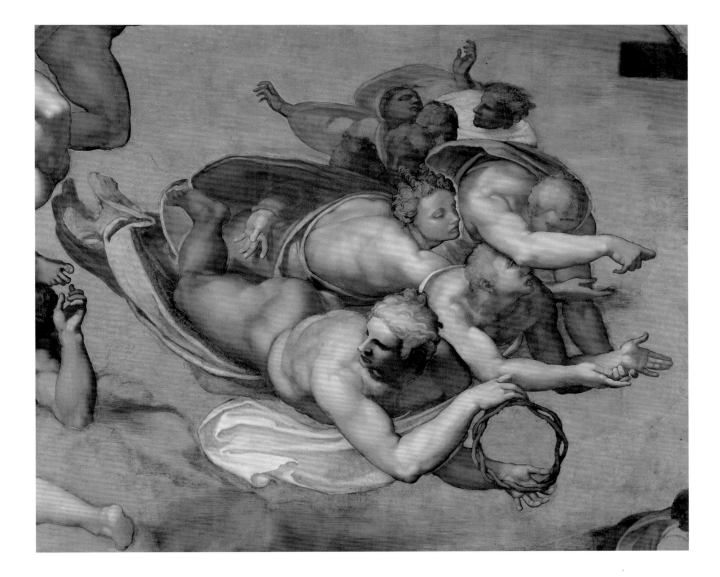

On page 99:
Michelangelo, *Last Judgement*

On these pages:
Michelangelo, *Last Judgement*, left lunette, *Angels with the Instruments of the Passion*

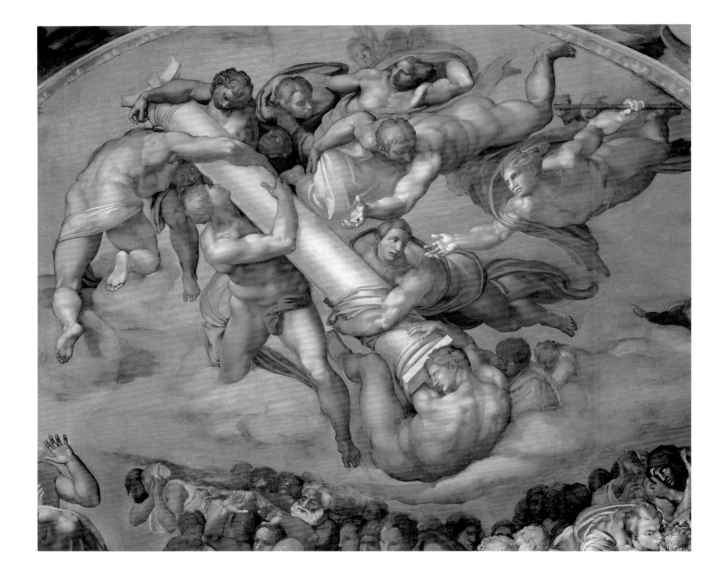

Michelangelo, *Last Judgement*, right lunette, *Angels with the Instruments of the Passion*

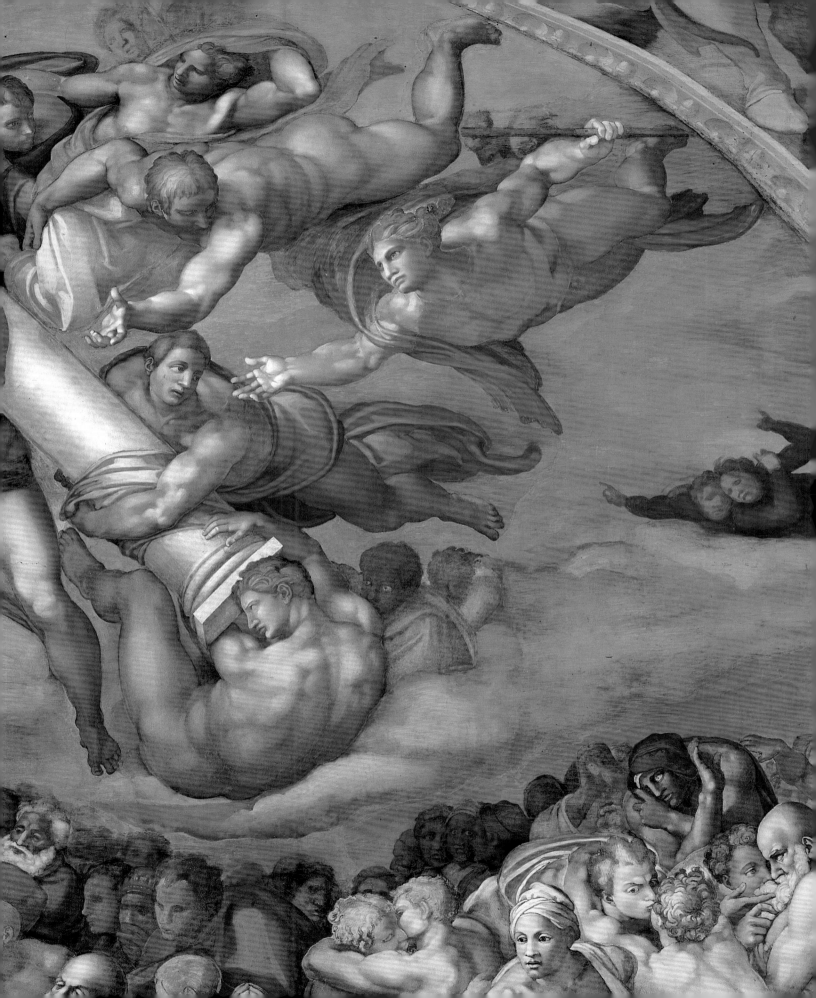

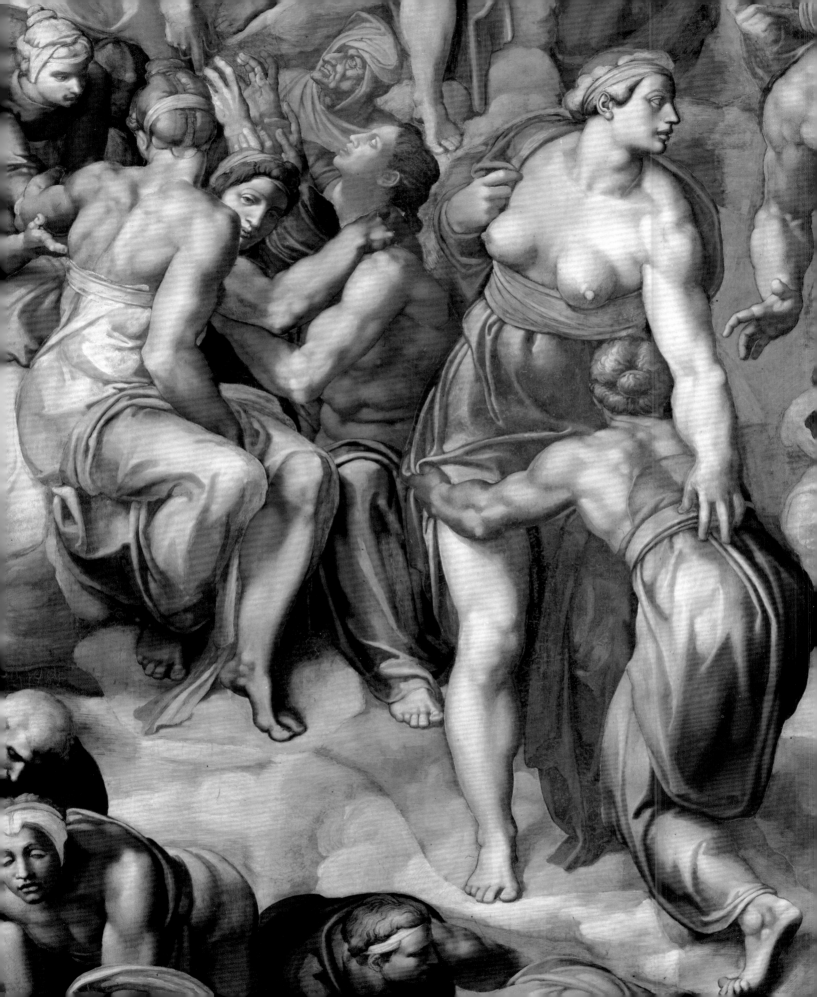

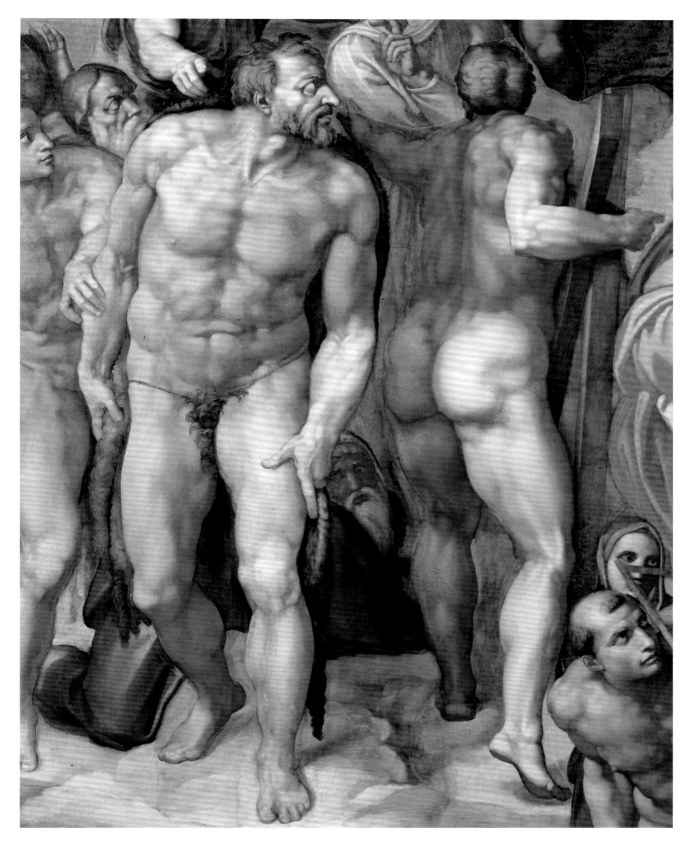

105

Michelangelo, *Last Judgement*, detail of the group of Sibyls with a Mother and her Daughter

Michelangelo, *Last Judgement*, detail with St. John the Baptist and St. Andrew

Michelangelo, *Last Judgement*, detail with Christ the Judge and the Virgin Mary surrounded by Saints

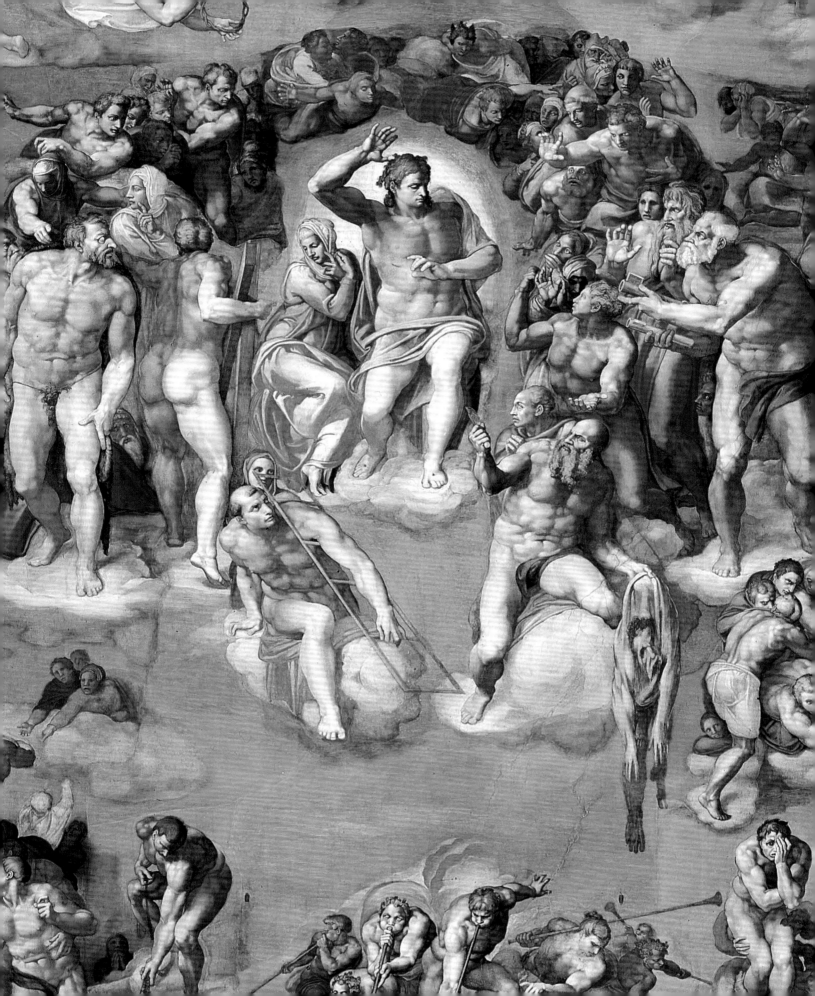

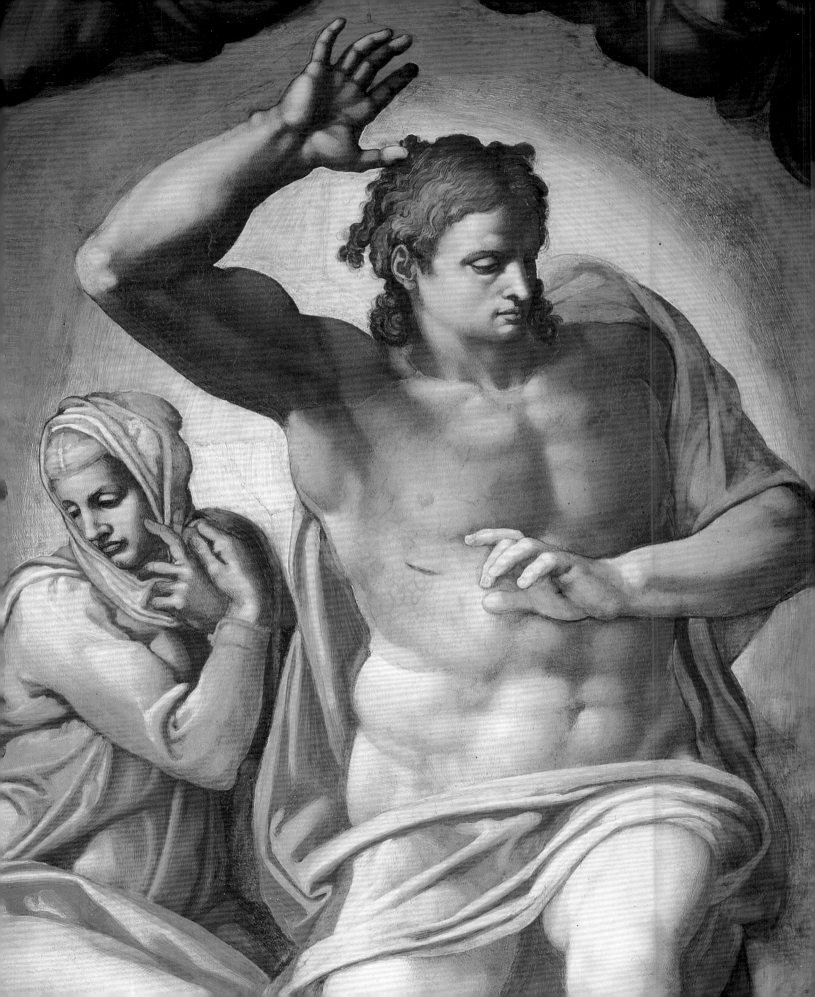

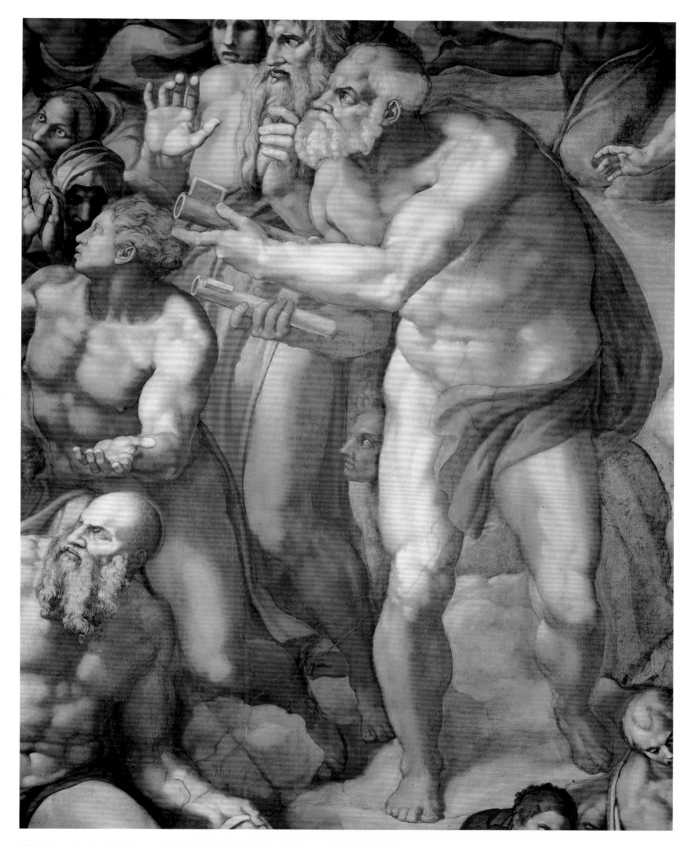

Michelangelo, *Last Judgement*, detail with Christ the Judge and the Virgin Mary

Michelangelo, *Last Judgement*, detail with St. Peter

Michelangelo, *Last Judgement*, detail of St. Bartholomew with a self-portrait of Michelangelo in the flayed skin

On pages 112-113:
Michelangelo, *Last Judgement*, detail with Trumpet-Playing Angels and Angels with the Book of the Elect and the Book of the Damned

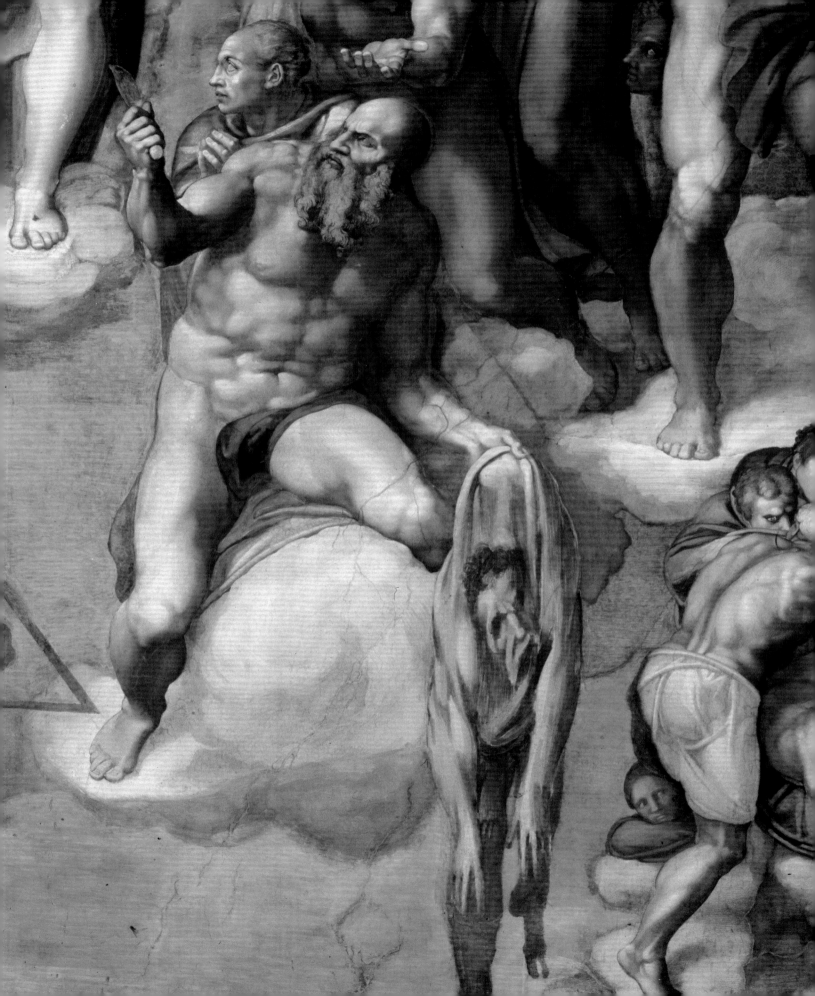

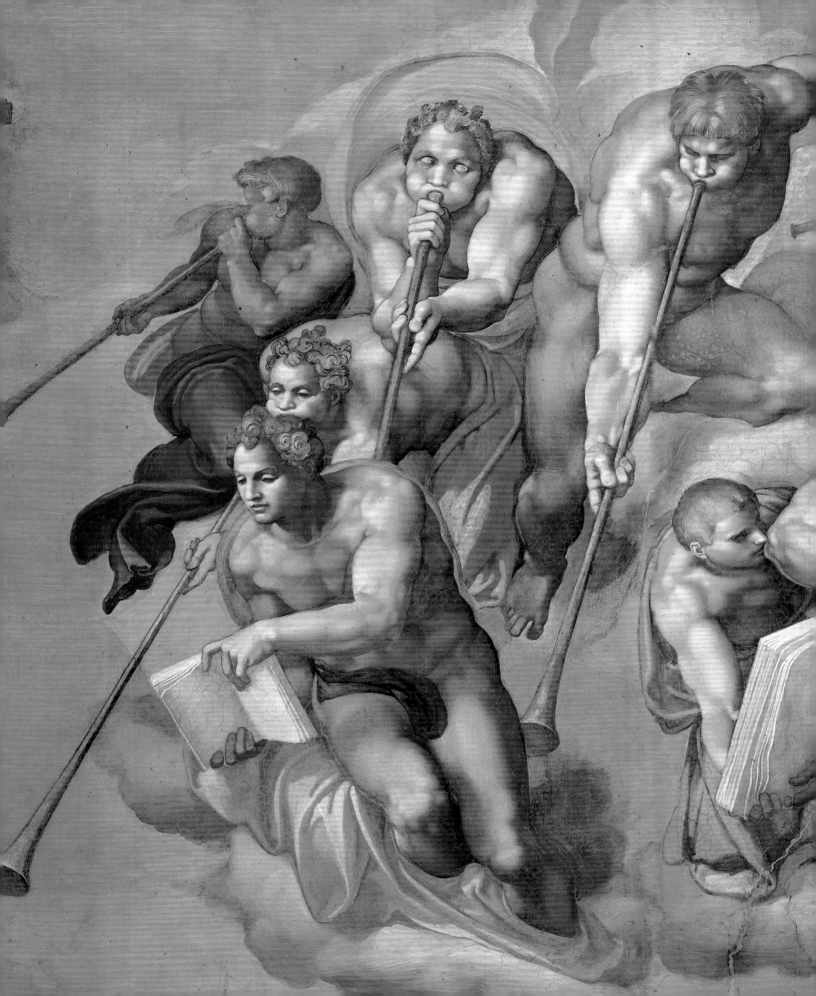

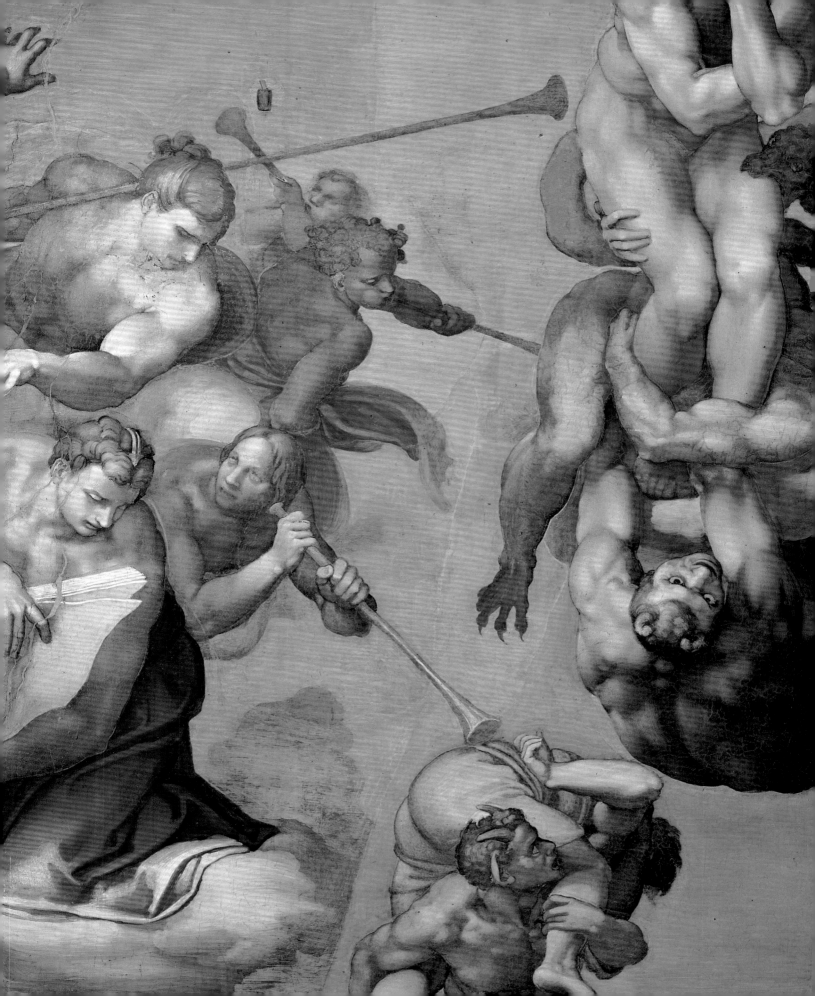

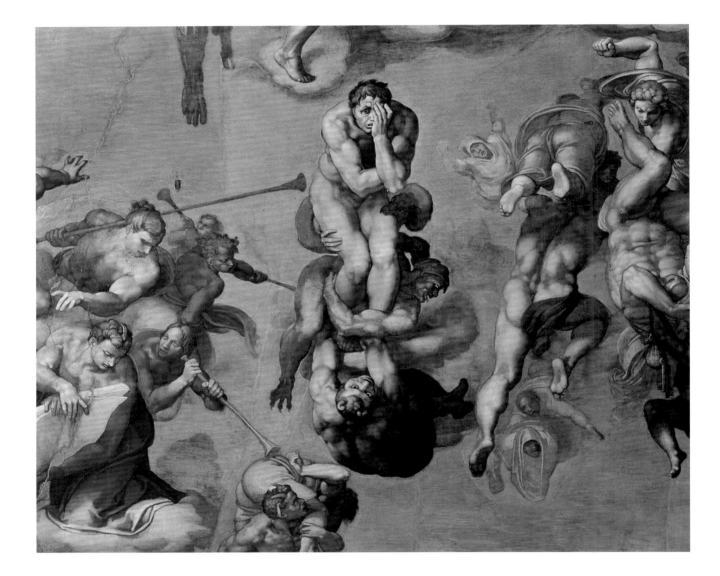

Michelangelo, *Last Judgement*, detail of the Reprobates

Michelangelo, *Last Judgement*, detail of the Seven Deadly Sins

On pages 116–117:
Michelangelo, *Last Judgement*, detail of the Resurrected ascending to Heaven

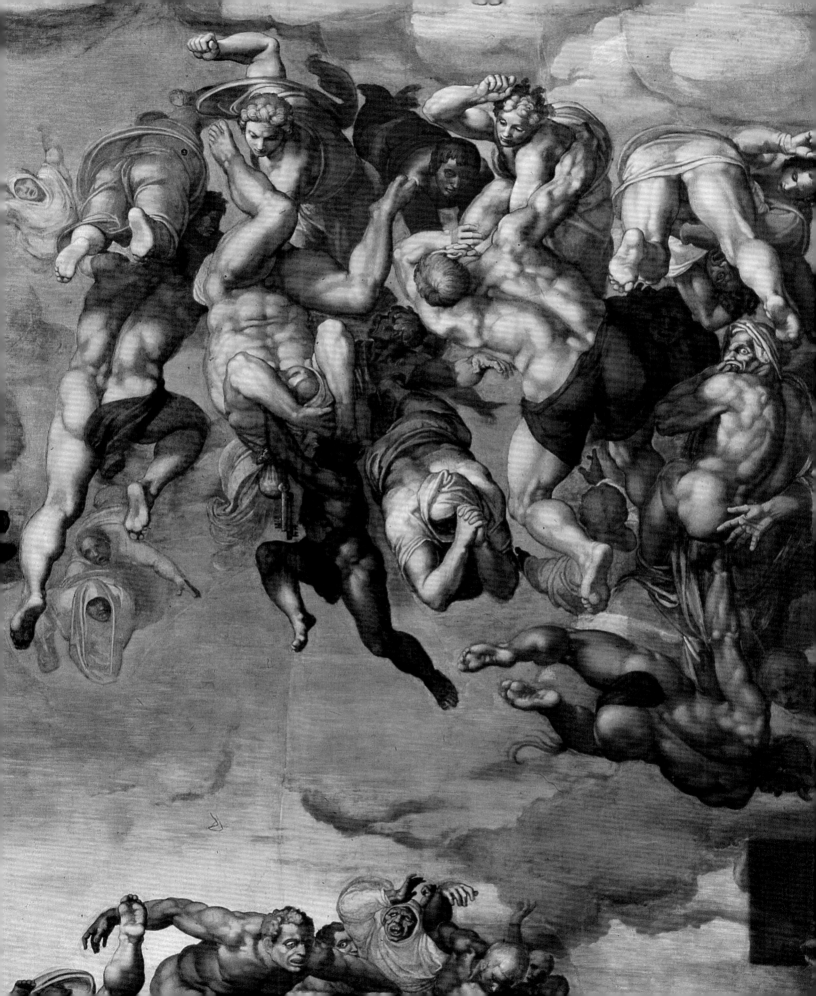

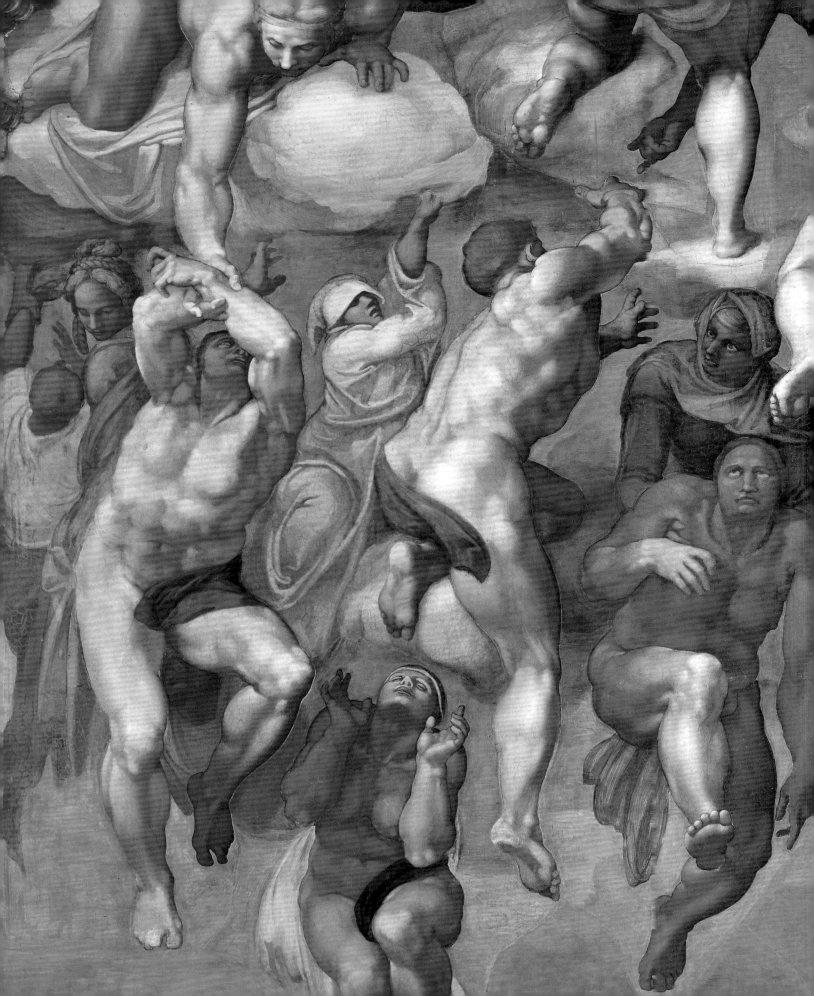

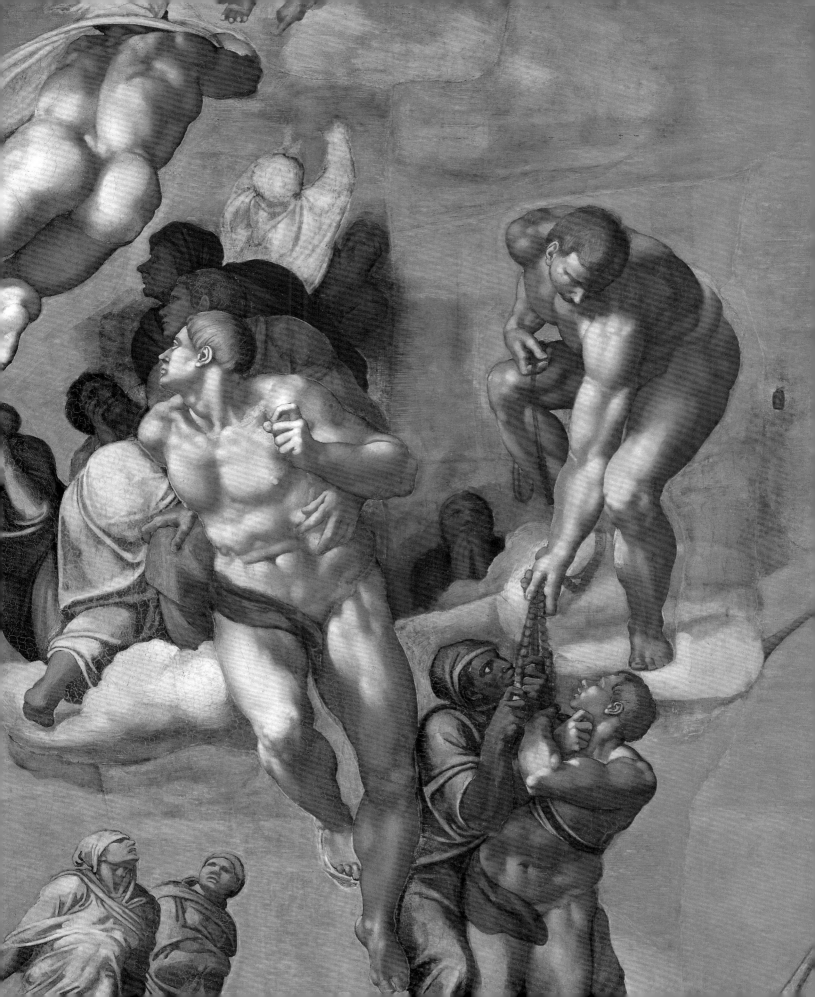

Michelangelo, *Last Judgement*, detail of the Resurrected ascending to Heaven

On pages 120–121:
Michelangelo, *Last Judgement*, detail of the Gates of Hell with the Boat of Charon and Minos, the Infernal Judge

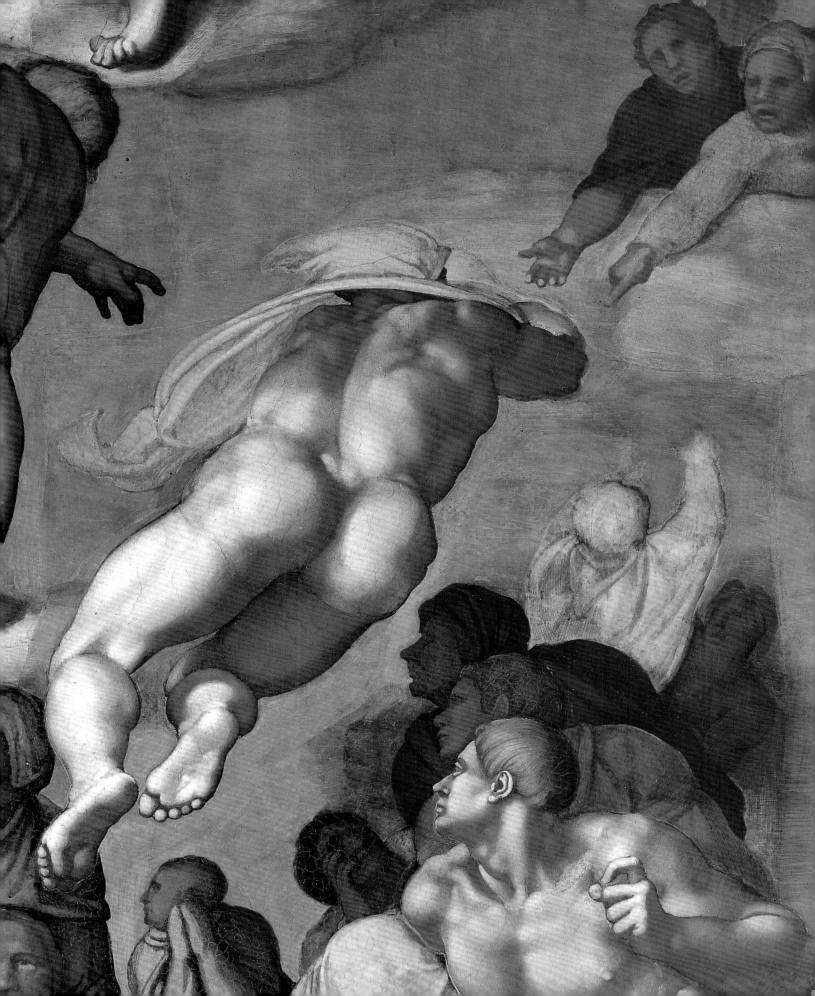

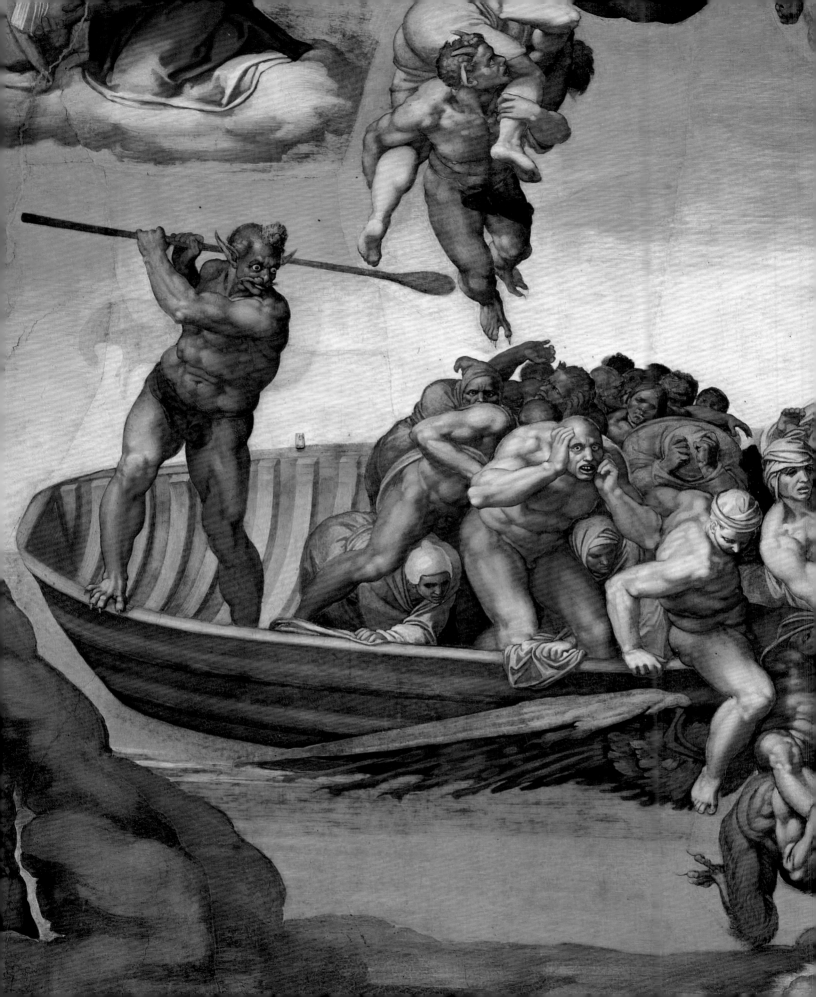

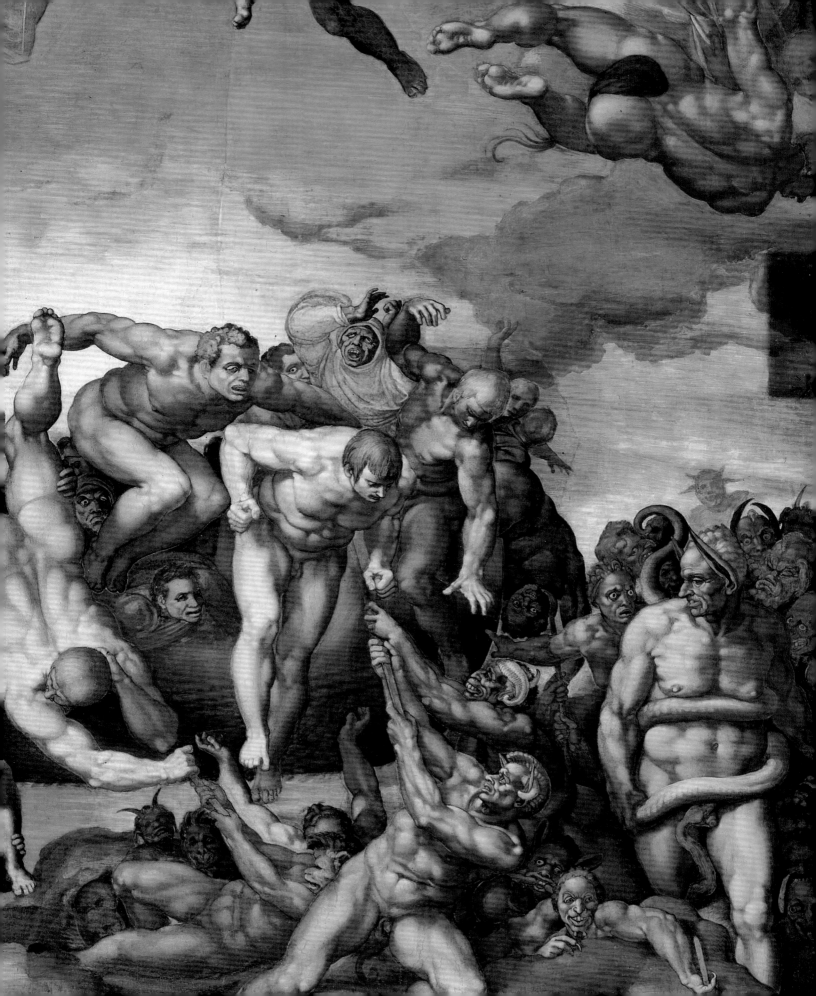

Appendix

The frescoes on the ceiling

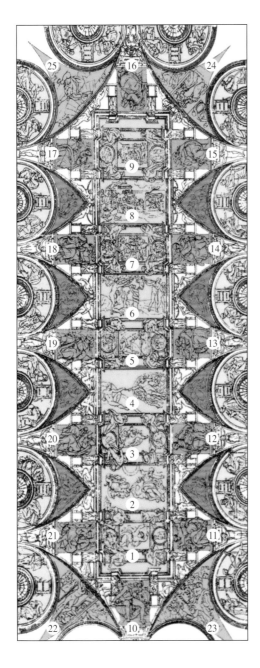

Central sections – Stories of Genesis
1 Separation of Light and Darkness
2 Creation of the Sun, the Moon and the Plants
3 Separation of Land from Water
4 Creation of Adam
5 Creation of Eve
6 Original Sin
7 Noah's Sacrifice
8 Flood
9 Drunkenness of Noah

Side sections – Seers (Prophets and Sibyls)
10 Prophet Jonah
11 Libyan Sibyl
12 Prophet Daniel
13 Cumaean Sibyl
14 Prophet Isaiah
15 Delphic Sibyl
16 Prophet Zechariah
17 Prophet Joel
18 Erythrean Sibyl
19 Prophet Ezekiel
20 Persian Sibyl
21 Prophet Jeremiah

Pendentives – Miraculous Salvations of Israel
22 Punishment of Haman
23 Bronze Serpent
24 Judith and Holofernes
25 David and Goliath

Lunettes – Ancestors of Christ

Webs – Ancestors of Christ

The Last Judgement

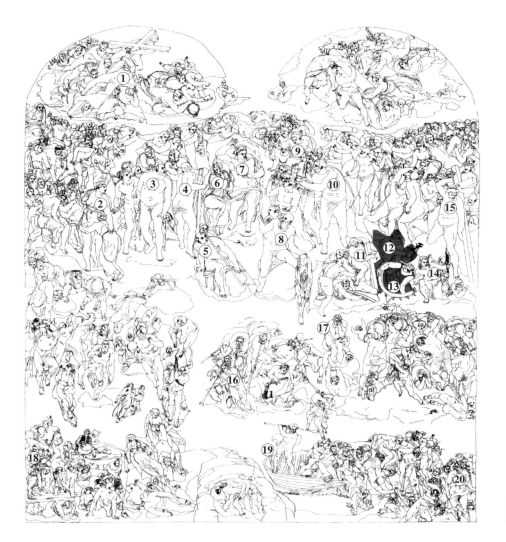

Additional dry overpainting

Additional fresco painting

1 Archangel Gabriel (?)
2 Niobe (or Eve, or the Church) (?)
3 St. John the Baptist
4 St. Andrew
5 St. Lawrence
6 Virgin Mary
7 Christ the Judge
8 St. Bartholomew
9 St. John the Evangelist (?)
10 St. Peter (or Paul III Farnese)

11 Dismas
12 St. Blaise
13 St. Catherine of Alexandria
14 St. Sebastian
15 Simon of Cyrene
16 Archangel Michael with the *Book of the Elect*
17 Proud or Desperate Expression Male Figure
18 Clement VII (?)
19 Charon
20 Minos (Biagio da Cesena)

This diagram marks out both the traditional identification of some of the figures in the Judgement, as well as the censored parts painted over by Daniele da Volterra (1565).

Index of the illustrations

The fifteenth-century decorations

Pietro Perugino, *Moses' Journey into Egypt*, pages 24–25
Sandro Botticelli, *Stories from the Life of Moses*, pages 26–27
Biagio d'Antonio, *Crossing of the Red Sea*, pages 28–29
Cosimo Rosselli, *Moses receiving the Tablets of the Law*, pages 30–31
Sandro Botticelli, *Punishment of Korah, Dathan and Abiram*, pages 32–33
Luca Signorelli and Bartolomeo della Gatta, *Testament of Moses*, pages 34–35
Pietro Perugino, *Baptism of Christ*, pages 36–37
Sandro Botticelli, *Temptations of Christ,* pages 38–39
Domenico Ghirlandaio, *Vocation of the First Apostles*, pages 40–41
Cosimo Rosselli, *Sermon on the Mount*, page 42
Mino da Fiesole, Choir, page 43
Sistine Chapel, Wall with False Drapes, pages 44–45
Mino da Fiesole and assistants, Sections of the Presbyterial Screen, pages 46–47
Pietro Perugino, *Consignment of the Keys to St. Peter*, pages 48–49
Cosimo Rosselli and Biagio d'Antonio, *Last Supper*, pages 50–51

Michelangelo's ceiling

Ceiling of the Sistine Chapel, page 53
Separation of Light and Darkness, pages 54–55
Creation of the Sun, the Moon and the Plants, pages 56–57
Separation of Land from Water, pages 58–59
Creation of Adam, pages 60, 61, 63, 64–65
Creation of Eve, pages 66–67
Original Sin and the Expulsion from Paradise, pages 68–69
Noah's Sacrifice, pages 70–71
Flood, pages 72–73
Drunkenness of Noah, pages 74–75
Prophet Jonah, pages 76–77
Libyan Sibyl, page 79